# LOVE AND RESISTANCE

# LOVE AND
# RESISTANCE

## OUT OF THE CLOSET
## INTO THE STONEWALL ERA

Photographs by Kay Tobin Lahusen and Diana Davies

From the New York Public Library Archives

Edited by Jason Baumann

With an Introduction by Roxane Gay

W. W. NORTON & COMPANY
*INDEPENDENT PUBLISHERS SINCE 1923*
NEW YORK  LONDON

For information about permission to reproduce selections from this book, write to
Permissions, W. W. Norton & Company, Inc., 500 Fifth Avenue, New York, NY 10110

For information about special discounts for bulk purchases, please contact
W. W. Norton Special Sales at specialsales@wwnorton.com or 800-233-4830

Manufacturing by Versa Press
Book design by Daniel Lagin
Production manager: Julia Druskin

ISBN 978-1-324-00206-2

W. W. Norton & Company, Inc., 500 Fifth Avenue, New York, N.Y. 10110
www.wwnorton.com

W. W. Norton & Company Ltd., 15 Carlisle Street, London W1D 3BS

1 2 3 4 5 6 7 8 9 0

*This book is dedicated to the activists depicted in these photographs, whose vision and courage changed our world, and to the staff of the New York Public Library, who have preserved this history for future generations.*

# Contents

# Preface

The photographs of Kay Tobin Lahusen and Diana Davies are among the great queer treasures of the New York Public Library. The library holds major collections of their work in its Manuscripts and Archives Division, which has one of the largest collections of LGBTQ and AIDS activist history in the United States. For me personally, Lahusen's and Davies's photographs have been a guide to the characters, events, and movements in LGBTQ history in the 1960s and '70s. When I first started working on the library's LGBTQ Initiative in 2008, my background was in LGBTQ literature and poetry. Though I had been a member of the AIDS activist organization ACT UP and a longtime member of the gay liberation movement the Radical Faeries, I didn't know that gay and lesbian activists had marched on the Pentagon in 1965 or that the lesbian activists with Lavender Menace had disrupted the National Organization for Women's conference in 1970. I didn't know about the dances at the Gay Activists Alliance Firehouse or the drag queen activism of Lee Brewster with the Queens Liberation Front either. Lahusen's and Davies's photographs provided me with a map to a generation of LGBTQ activism. It has been an honor for my colleagues at the library and me to help preserve and share this history with researchers and the public.

Although their photographs are widely cited and reproduced in histories of LGBTQ politics and culture, little attention has been paid to Lahusen and Davies themselves. When we started the library's LGBTQ Initiative, one of our first prior-

ities was digitizing the entire archive of Lahusen's and Davies's photographs. This has greatly expanded access to their work but hasn't always provided them with the recognition that they deserve. On the internet, images are often taken out of context and are presented without proper attribution. Besides which, like so many photographers, they preferred to be behind the camera and out of the spotlight.

In 2019, the library is holding an exhibition called "Love and Resistance: Stonewall at 50" to commemorate the fiftieth anniversary of the Stonewall Riots and to give the public a look into the depth and breadth of our archives. This exhibit will document the growth of national political consciousness in LGBTQ communities in the 1960s leading up to the Stonewall Riots and the tremendous explosion of LGBTQ culture and activism in the 1970s. By featuring Lahusen's and Davies's photographs along with political ephemera, posters, flyers, magazines, newspapers, and artifacts, we hope to illuminate the history of this period in context. This volume is an opportunity to focus just on the photographers' achievements.

In this book we have attempted to bring Lahusen's and Davies's photographs into conversation. At first glance, they might seem like an odd pairing. Lahusen came of age during the homophile activist movement of the 1960s. As one can see in her photographs of demonstrations in Washington, D.C., in 1965, a small but pioneering cadre of LGBTQ activists at that time courageously demanded a place at the table in society, often focusing on civil rights related to employment, including the right to serve in the military. She later aligned with the Gay Activists Alliance (GAA), which took a rights-based approach to LGBTQ activism in the 1970s, focusing on civil rights legislation and the right to privacy, in addition to community building. One of their main initiatives in New York in the '70s was working for the passage of antidiscrimination legislation. Both the homophile activists and GAA were reformist in character, fighting to make space for gays and lesbians in society. In contrast, Davies was in the thick of the Gay Liberation Front (GLF), the Radicalesbians, and Street Transvestites Action Revolutionaries (STAR), which endeavored to embrace a wider range of feminist, Marxist, transgender, and antiracist perspectives. Instead of working for rights-based inclusion in existing institutions, the GLF called for the radical questioning of society as a whole, including the nuclear family and the government. They were calling for revolutionary cultural transformation.

Viewed in tandem, one can see that Lahusen and Davies each attempted to bring a new perspective to depictions of LGBTQ people. And they often provide complementary views of pivotal people and events. In fact, although these two political tendencies are often seen as opposing forces in gay liberation, through these photographers' pictures one can see that there was tremendous crossover among these communities. For instance, Davies's pictures capture GLF, Radicalesbian, and STAR members at a rally for Intro 475, which was an early antidiscrimination bill in New York. And Lahusen's photos document transgender activists like Sylvia Rivera and leather and fetish activists at gay liberation conferences. Both of them documented the early Christopher Street Liberation Day marches, so we can see those events through both of their eyes. Viewing their works in conversation offers us a deeper understanding of the web of LGBTQ liberation movements of the era, and of both of their ranges as documentary photographers and their values as individual activists.

———

KAY LAHUSEN WAS BORN IN CINCINNATI, Ohio, in 1930. She became involved in the homophile movement in 1961, when she joined the Daughters of Bilitis, the first national organization for lesbians in the United States. Founded in San Francisco in 1955, the Daughters of Bilitis served as a forum for lesbians to meet and discuss identity, politics, and literature. Like many other early LGBTQ rights groups at the time, they held social events and public forums about homosexuality; they also published a journal. Lahusen soon met activist Barbara Gittings, founder of the East Coast chapter of the Daughters of Bilitis, who became her partner, in activism and in life. In 1964, Gittings was appointed editor of *The Ladder*, the group's magazine, and Lahusen became its art editor, working under the pseudonym Kay Tobin. Lahusen, who had owned a box camera as a child, had always been interested in photography. She quickly and thoroughly transformed the visual identity of *The Ladder*, which had previously featured line drawings and cartoons for covers and illustrations. Lahusen and her subjects took a leap and replaced the publication's timid illustrations with bold photographs of actual living lesbians. Her photos depicted lesbians as happy, capable, vibrant human beings, often in couples,

although at times they were pictured wearing sunglasses or photographed from behind to protect their anonymity. The lesbians in her pictures have lives, lovers, and careers. In the two years of her tenure as art editor of *The Ladder,* Lahusen and the other photographers she enlisted created a new image for lesbians in the United States, going beyond the tragic and lurid caricatures of psychiatry and pulp fiction.

In addition to their editorial and photographic work in the 1960s, Lahusen and Gittings participated in some of the most pioneering LGBTQ political demonstrations in the United States, marches for gay rights on the White House, the Pentagon, and Independence Hall in Philadelphia, which Lahusen documented for the emerging gay and lesbian press. After the Stonewall Riots in 1969, Lahusen was a professional photojournalist in the gay press, amassing an archive of almost a thousand photographs that are now in the New York Public Library's collection.

Diana Davies, born in 1938, is one of the most important photographers to document the feminist, peace, and civil rights movements of the 1960s and '70s, as well as American folk music and women's music festivals. She is also a musician, visual artist, and playwright, as well as a peace and social justice activist. She published a survey of her photographs in 1989 under the title *PhotoJourney: Photographs.* In the 1990s, she would give up photojournalism to focus on drawing and painting, but in the late 1960s and early '70s, Davies was a contributor to *Come Out!,* a GLF publication, and also published photographs in *Gay Power* and other fledgling LGBTQ periodicals. Davies's photos from this period capture a generation of the most original voices in LGBTQ activism. The photos document the aftershocks of the Stonewall Riots, the birth of the gay liberation movement, and the emergence of radical lesbian feminism. They also provide some of the most iconic images of pioneering transgender activists Marsha P. Johnson and Sylvia Rivera. Like Lahusen before her, Davies was both an activist and a documentarian. Both women risked confrontation and arrest in the process; their photos are from the front lines of some of the most dramatic demonstrations of the time.

LAHUSEN'S AND DAVIES'S PHOTOGRAPHS illuminate the tremendous range of LGBTQ activism from the mid-1960s to the mid-1970s. Together they documented

LGBTQ demonstrations in New York, Washington, D.C., New Jersey, and Pennsylvania, as well as portraits of prominent activists from around the United States. Although there is a focus in their photographs on events in New York, parallel and connected movements were happening across the country.

The photographs in this volume are organized into four parts, each centered around a mode of resistance—visibility, love, pride, and protest. "Visibility" features the pair's portraits of LGBTQ activists and everyday people. By creating compelling, human portraits of gays, lesbians, bisexuals, and transgender people, Davies and Lahusen resisted their dehumanization by society. "Love" gathers their photographs depicting couples, resisting homophobia by illustrating the revolutionary possibilities of love and intimacy in the face of hate. "Pride" illustrates the ways that LGBTQ communities resisted oppression by creating their own alternative spaces through nightlife, marches, community centers, and print culture. "Protest" is ordered chronologically to showcase the progression of major demonstrations and activism; in this series we can see the evolution in priorities and tactics of LGBTQ activists, and how they used forms of disguise and theater in their demonstrations as forms of resistance.

The language for discussing sexuality and gender identity has undergone tremendous changes throughout the past century, and the activists depicted in these photographs had a wide range of ways of describing themselves. In particular, the terms *homosexual* and *transvestite* appear extensively in the photographs and were in popular usage during the third quarter of the twentieth century. Although it may at times be anachronistic, I have used the terms *gay, lesbian, bisexual, transgender,* and *queer*, as well as the acronym *LGBTQ*, throughout this book to better reflect the language commonly in use today. In the descriptions of the photographs I have attempted to identify the activists depicted based upon Lahusen's and Davies's own notes. However, identifying everyone was not possible. Many of these activists went by pseudonyms to protect their identities or took new names in order to better express themselves. I have respected the names they chose for themselves, but have pointed out a few instances where people were known by multiple names. Throughout the text I have referred to people known to be deceased solely in the past tense. Naturally, the constellation of activists presented does not cover every

activist of importance during this era, but the selection does reflect Lahusen's and Davies's own perspectives, experiences, and archives. In keeping with the archival spirit of this book, the photographs are presented in their original state, including editing marks.

Reviewing these photographs again for this book, I was struck by how many of the themes resonate with our current political moment. Given the deep divides and fierce debates currently taking place in the United States regarding gender, sexuality, race, and power, Lahusen's and Davies's photographs seem as timely now as when they were first taken. Although images of gays, lesbians, bisexuals, and transgender people are more prominent in popular culture than ever before, they are still not commensurate with the range of our actual lived experiences. With decriminalization of homosexuality, the legalization of marriage equality in the United States, and the acceptance of out LGBTQ people in the U.S. armed forces, many activists are left wondering whether the goal was simply acceptance into broader society as it is, or the transformation of our society. It is too easy to see human history as a long self-congratulatory narrative of progress, but the truth is that the status of gays, lesbians, bisexuals, and transgender people has evolved for better and for much worse throughout history. There have been eras of relative openness and eras of severe oppression. Although the freedoms that have been won in the past fifty years are remarkable, they are not guaranteed, as we're seeing now, when the right to military service is endangered by conservative movements. In order to maintain and expand these liberties, we have to remember these historical struggles and the bravery of the people who resisted before us.

—Jason Baumann

# Introduction

Queer people have often lived in the margins. We have been forced to hide in plain sight. We have had to fight for the right to love openly, to marry, to earn a living without being discriminated against because of our sexuality, to live with dignity. Queer culture thrives and has always thrived because resistance is as deeply embedded in who we are as our sexuality.

When we think about queer resistance we, rightly, talk about the Stonewall Riots in June 1969. At that time, homosexuality was still classified as a mental illness by the *Diagnostic and Statistical Manual* used by mental-health professionals. The LGBTQ community was reeling from McCarthyism and a pernicious atmosphere of persecution across the country. When police raided the Stonewall Inn, a popular gay bar in New York City, the patrons refused to go meekly. Instead they resisted. For six days and nights, thousands of queer people, led by trans women like Marsha P. Johnson, rioted—and those riots begat years of vigorous activism and resistance. A year after the riots, the first gay pride parade was held in New York City; fifty years later, pride celebrations continue throughout the world.

The LGBTQ community continues to resist oppression in all kinds of ways—from simply living our lives and loving whom we choose, to raising families, to defying convention, to celebrating our sexuality and the communities we have chosen,

to protesting injustice and inequality. We thrive because we resist, but we also thrive because, at our best, we live joyfully.

Because we have, all too often, lived our lives in the margins, it is important to document and preserve our history. It is important to show that we are here now, but have always been here, whether you chose to see us or not.

This book, *Love and Resistance: Out of the Closet into the Stonewall Era*, is particularly timely because although we have come a long way, we are once again—by way of the actions of the Trump administration—reminded of how far we have yet to go. Our lives are still legislated according to the whims of those in power, those who, all too often, believe we do not have the right to live openly, to love openly, to thrive openly. The images here document LGBTQ life and activism during the 1960s and 70s, a time when queer people were emerging from the margins and asserting their right to do so. Here you will find images of people who were active in the LGBTQ community. There are images of couples and the intimacies they shared. There are images of protest and the LGBTQ community demanding to be seen and heard. This was the beginning of the modern era of queer resistance, but it was not the end. The images in this book are, above all, a reminder of how powerful we are when we resist.

—Roxane Gay

# LOVE AND RESISTANCE

# VISIBILITY

The 1960s and '70s saw the emergence of open and organized protests for civil rights by LGBTQ people, the explosion of LGBTQ news and print culture, and an entire generation of people who were willing to come out of the closet in order to transform societal prejudices and stereotypes. For people to organize politically based on their oppression due to their sexual orientation or gender identity was almost unprecedented. Those who did risked their livelihoods, families, safety, and freedom.

Kay Tobin Lahusen and Diana Davies knew that the friends and colleagues whom they photographed were making history. Their archives are rich in portraiture, with grassroots activists depicted with drama, force, and grace. In addition to documenting their subjects' bravery, Lahusen and Davies also intended their portraits as a corrective to the negative images of gays, lesbians, bisexuals, and transgender people in popular culture. The activists of this era realized that one of the most profound actions they could take to resist society's oppression of LGBTQ people was to publicly affirm their differences and their essential human dignity. These photos reveal a full range of people—from ministers and carpenters to secretaries and psychiatrists—challenging stereotypes of LGBTQ lives. Lahusen and Davies were there capturing this revolutionary moment, which is perhaps best encapsulated by the Gay Liberation slogan "Come Out!"

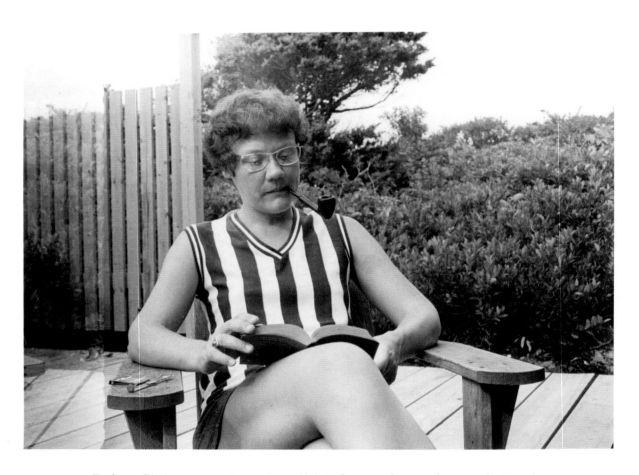

Barbara Gittings was a pioneering activist whose work ranged across the Daughters of Bilitis, Gay Activists Alliance, and the National Gay Task Force, as well as with the American Psychiatric Association and the American Library Association. Gittings and Lahusen met at a picnic in 1961 and were partners until Gittings's death in 2007.

*Kay Tobin Lahusen, 1970.*

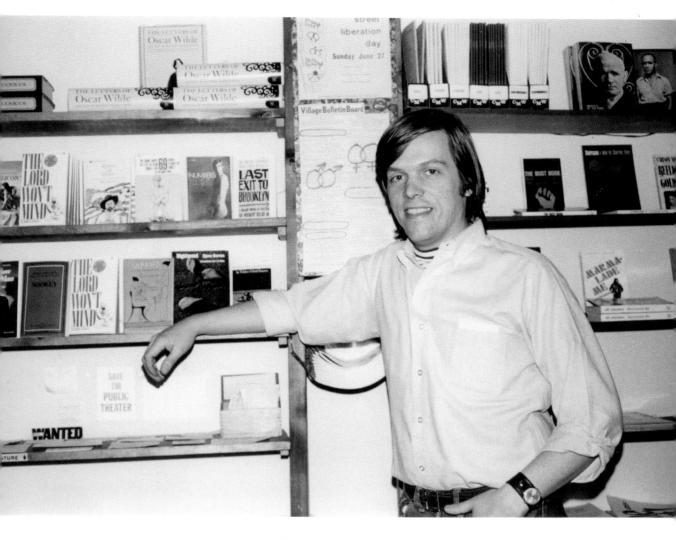

Activist and writer Craig Rodwell may be best known for opening the Oscar Wilde Memorial Bookshop in 1967. Rodwell intended the store to provide gays and lesbians with a visible community space as well as an alternative to the many pornographic bookstores operating at the time. Rodwell was also a member of the Mattachine Society of New York and Homophile Youth Movement in Neighborhoods, and he helped to organize Christopher Street Liberation Day, the first LGBTQ pride march, in 1970.

*Kay Tobin Lahusen, 1971.*

Ernestine Eckstein was vice president of the New York chapter of the Daughters of Bilitis in the 1960s. She was also involved in the NAACP and the Congress of Racial Equality (CORE). Eckstein was an early proponent of picketing and demonstrations as key political tactics for LGBTQ activists, participating in the pickets of the White House in 1965 and the annual "reminder" marches in Philadelphia in the late 1960s, intended to remind the nation of the injustices faced by gays and lesbians. She later joined the Black Women Organized for Action (BWOA) in San Francisco, in the 1970s.

*Kay Tobin Lahusen, 1966.*

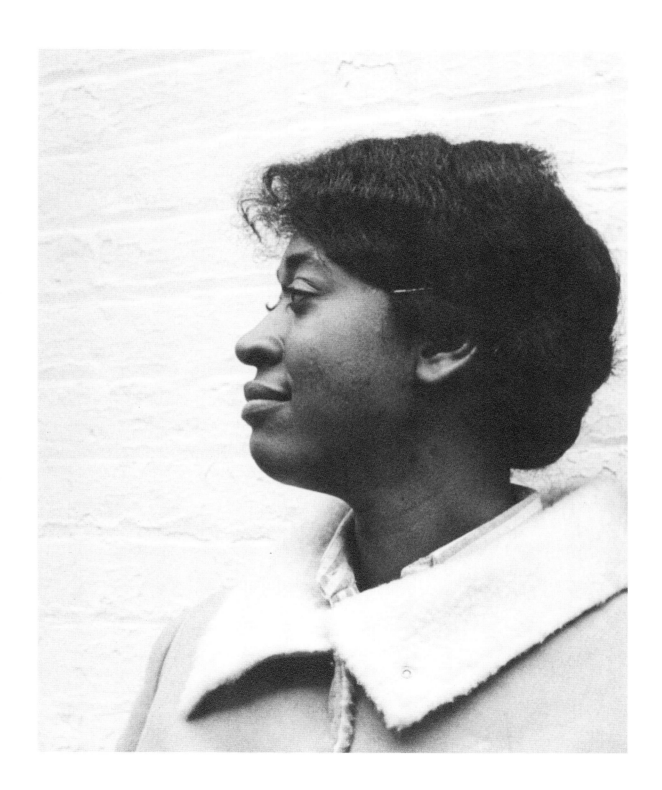

Identified as "Carol," this photograph ran as the cover of the May 1966 issue of *The Ladder*. The illustrations and photographs in *The Ladder* often obscured their subjects' identities using sunglasses or depicting them from behind. At the time, homosexual activity was illegal in most states and was classified as a mental illness. Out lesbians risked losing their jobs and families, and they faced imprisonment and psychiatric institutionalization.

*Kay Tobin Lahusen, 1966.*

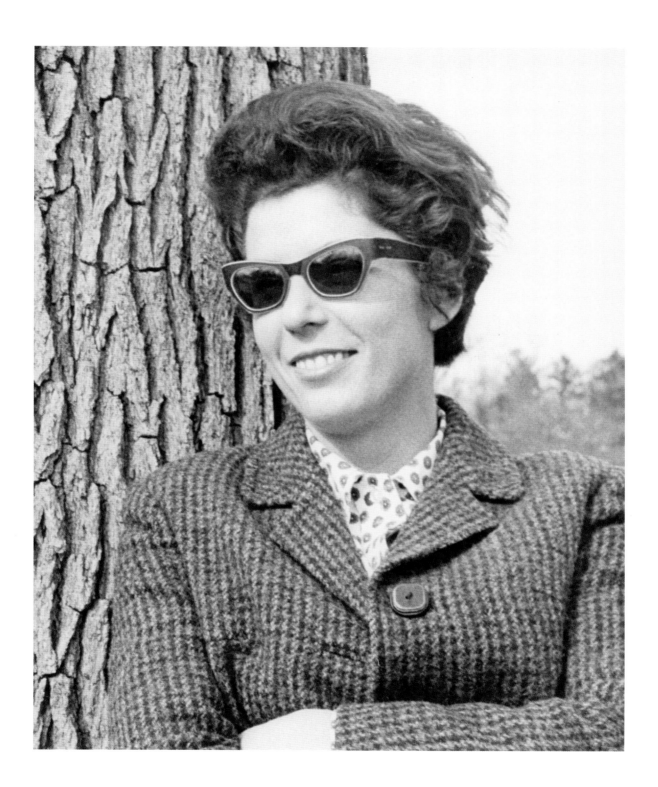

Frank Kameny devoted his life to activism after he was dismissed from a U.S. civil service position for being gay in 1957. Kameny fought his dismissal in the courts, all the way up to the Supreme Court. Although he lost his appeal, the case set a crucial precedent as the first known civil rights claim based on sexual orientation pursued in a U.S. court. He cofounded the Mattachine Society of Washington, D.C., and was the first openly gay candidate to run for United States Congress.

*Kay Tobin Lahusen, 1971.*

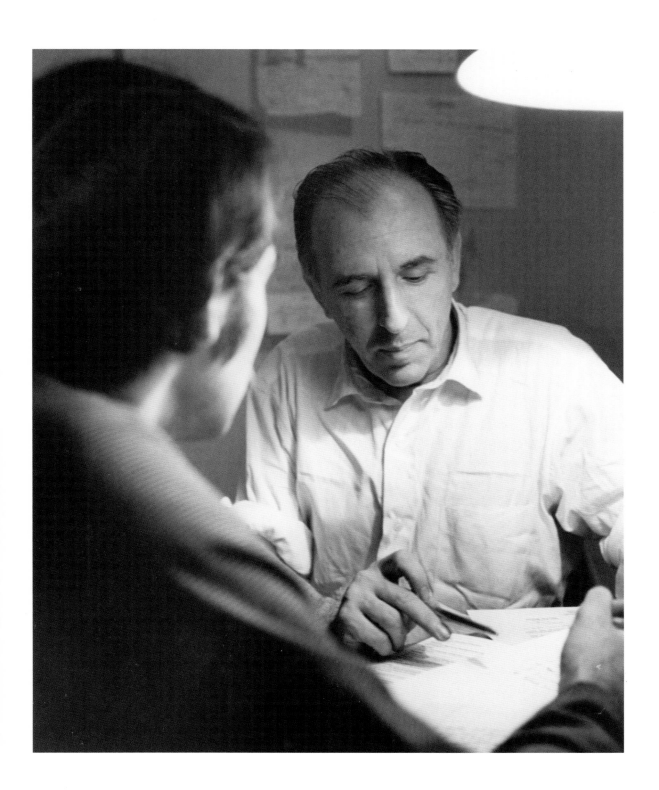

Activist Marsha P. Johnson cofounded STAR (Street Transvestites Action Revolutionaries) with Sylvia Rivera in 1970. Johnson participated in the Stonewall Riots and was an activist with the Gay Liberation Front, and later the AIDS activist organization ACT UP. Johnson also performed in the queer performance troupe Hot Peaches and posed for Andy Warhol. She remains to this day a beloved icon of the LGBTQ activist community in New York City.

*Diana Davies, 1971.*

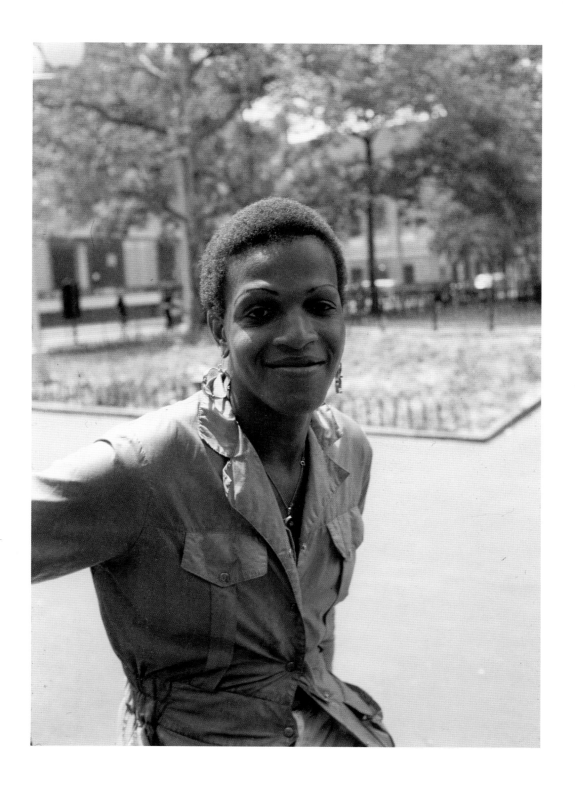

Activist and writer Dick Leitsch, pictured here in conversation with Barbara Git-
tings, was president of the New York chapter of the Mattachine Society in the mid-
1960s and helped shift their focus to demonstrations and direct action during his
tenure. He helped organize a "sip-in" in 1966, to protest the New York State Liquor
Authority's policy of not allowing bars to serve gays and lesbians on the grounds
that homosexuality constituted disorderly conduct.

*Kay Tobin Lahusen, 1967.*

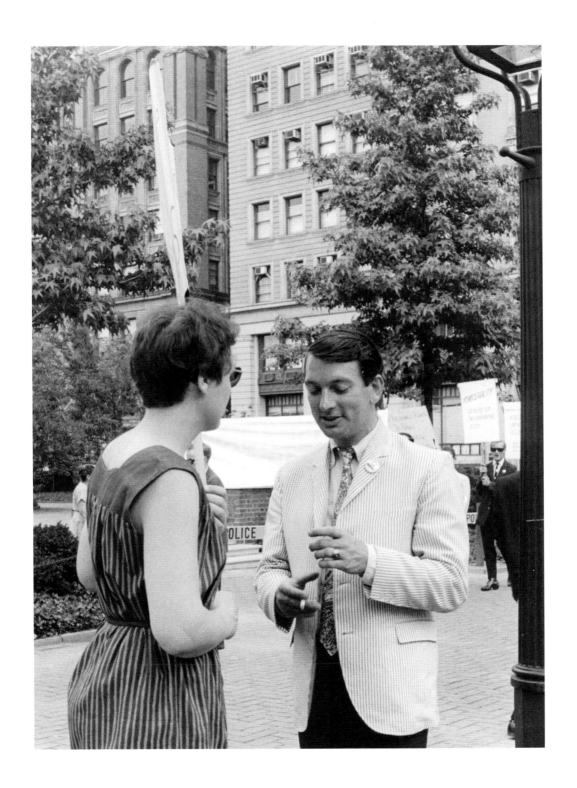

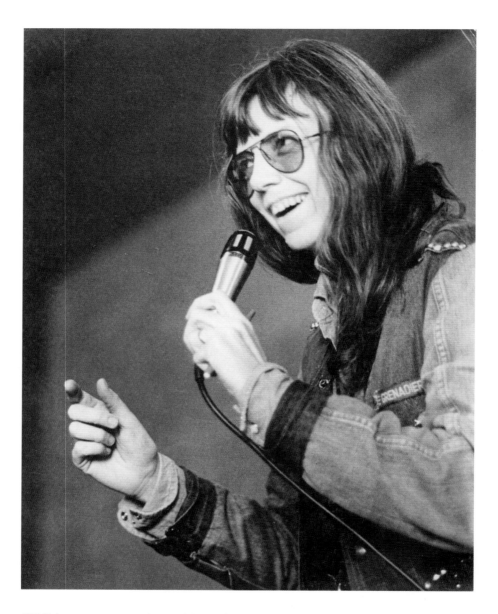

Jill Johnston was a writer, critic, and activist. She wrote for the *Village Voice* and authored ten books, including *Lesbian Nation: The Feminist Solution* (1973), which was a pivotal book in the emergence of lesbian feminism. Her funny, smart, erotic writing boldly combined New Journalism and feminist critique.

*Diana Davies, 1970.*

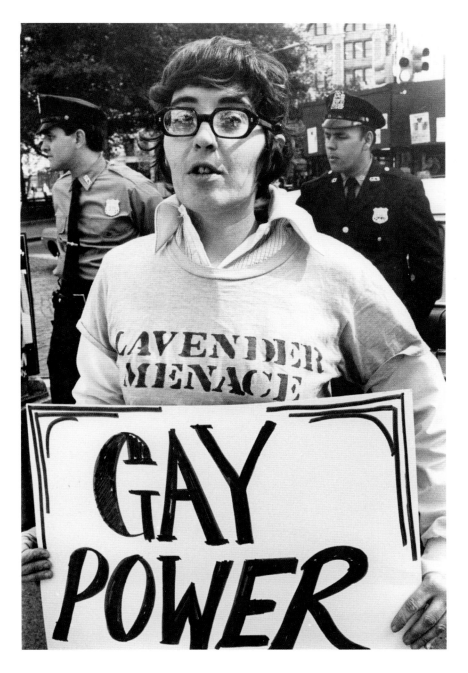

"Ida," pictured here with a "Gay Power" sign, was a member of the Gay Liberation Front and Lavender Menace.

*Diana Davies, 1970.*

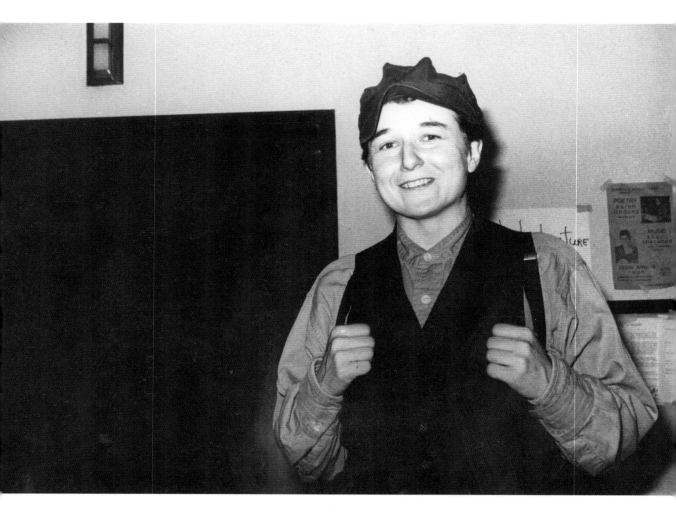

Luke Carsin was an anarchist and activist who participated in the art and performance scene in New York City's East Village during the 1970s and '80s.

*Diana Davies, 1970s.*

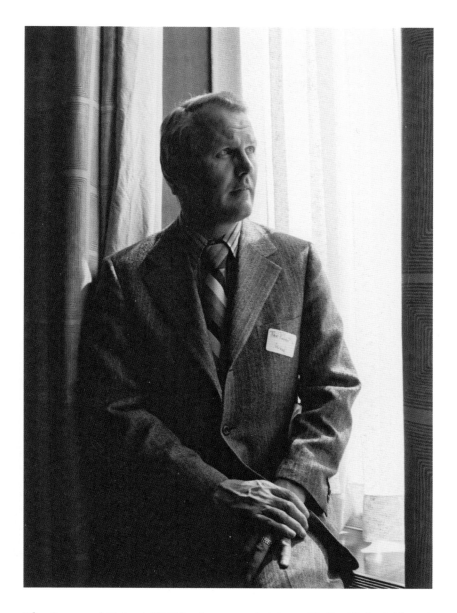

The Reverend Robert W. Wood was a minister with the United Church of Christ and one of the first openly gay members of the Christian clergy. In 1960 he published *Christ and the Homosexual,* and later that decade he would march in the annual "reminder" marches at Independence Hall in Philadelphia.

*Kay Tobin Lahusen, 1971.*

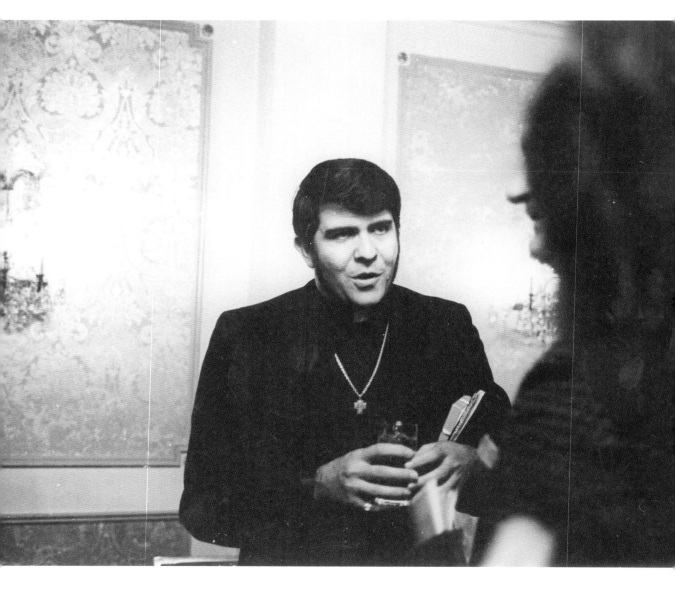

Troy Perry founded the Metropolitan Community Church in Los Angeles in 1968. It would become an international Christian denomination ministering to lesbian, gay, bisexual, transgender, and queer communities, and it remains active to this day. Perry is the author of *The Lord Is My Shepherd and He Knows I'm Gay* (1972), *Don't Be Afraid Anymore* (1990), and *Profiles in Gay and Lesbian Courage* (1992).

*Diana Davies, 1970s.*

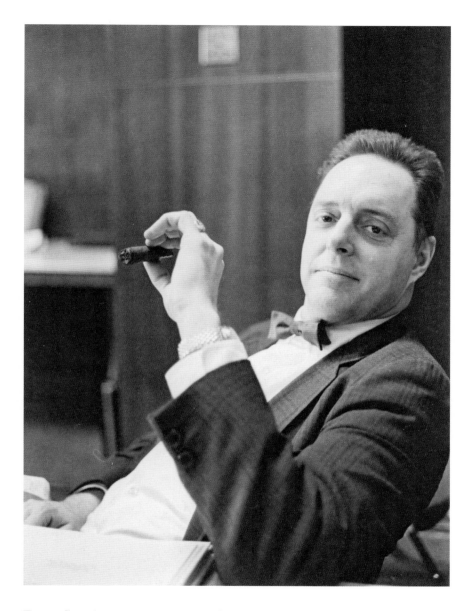

Foster Gunnison was an activist with the East Coast Homophile Organization (ECHO) and the North American Conference of Homophile Organizations (NACHO), organizations that worked to pull together gay and lesbian activists across the United States in the 1960s.

*Kay Tobin Lahusen, 1971.*

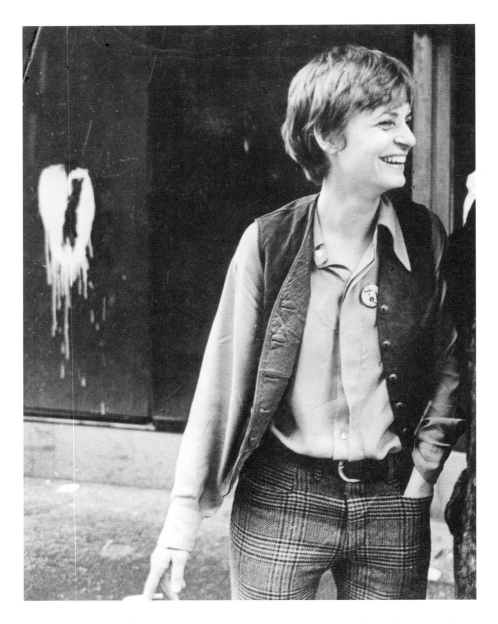

Pat Maxwell is a writer and activist who participated in the Gay Liberation Front and the Lavender Menace. Her writings were published in the periodicals *Gay Power*, *Come Out!*, and *Big Apple Dyke News*.

*Diana Davies, 1969.*

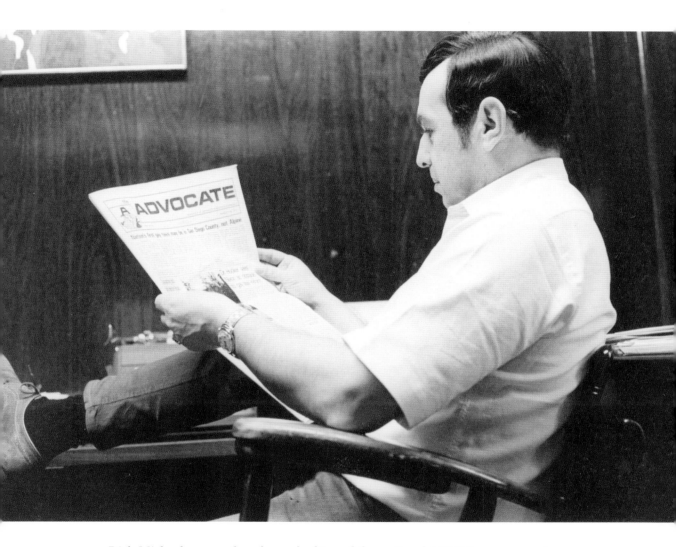

Dick Michaels was cofounder and editor of the national LGBTQ newsmagazine *The Advocate*, which he is shown reading here. Michaels's given name was Richard Mitch, but he operated *The Advocate* under a pseudonym to protect his identity. After pursuing a career in science journalism, Michaels became an activist following his arrest during a police raid of a gay bar in Los Angeles in the 1960s.

*Kay Tobin Lahusen, 1970.*

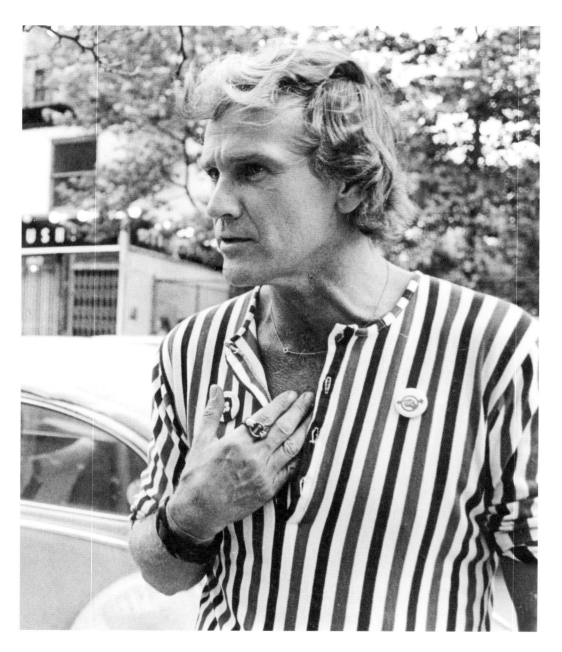

Bob Kohler was an activist and writer who participated in the Stonewall Riots, the Gay Liberation Front, and many other movements for LGBTQ liberation.

*Diana Davies, 1970.*

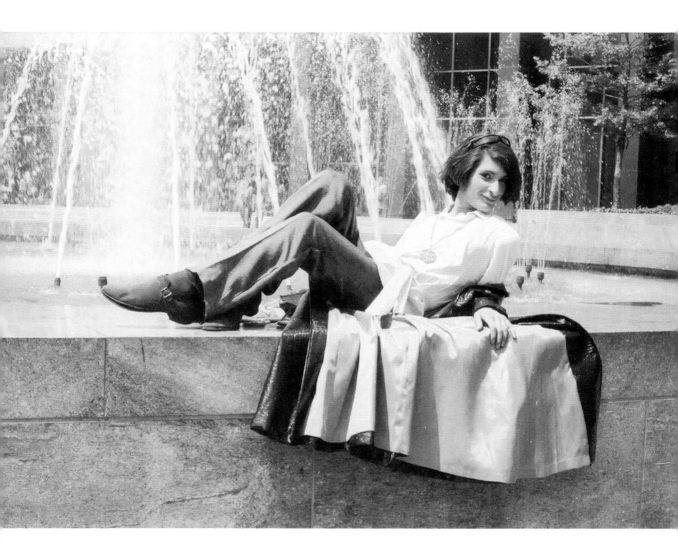

Sylvia Rivera was a pioneering transgender activist who cofounded Street Trans-
vestites Action Revolutionaries with Marsha P. Johnson. She also worked with the
Gay Liberation Front and Gay Activists Alliance. Rivera was a tireless advocate for
the rights of transgender people, queer youth, the homeless, and the mentally ill
until her death in 2002.

*Kay Tobin Lahusen, 1970.*

Betty Berzon was a psychotherapist and writer. In 1971, she became the first mental health professional in the United States to come out of the closet. Her books included *Permanent Partners: Building Gay and Lesbian Relationships That Last* (1988), *The Intimacy Dance: A Guide to Long-Term Success in Gay and Lesbian Relationships* (1996), and *Setting Them Straight: You Can Do Something About Bigotry and Homophobia in Your Life* (1996).

*Kay Tobin Lahusen, 1977.*

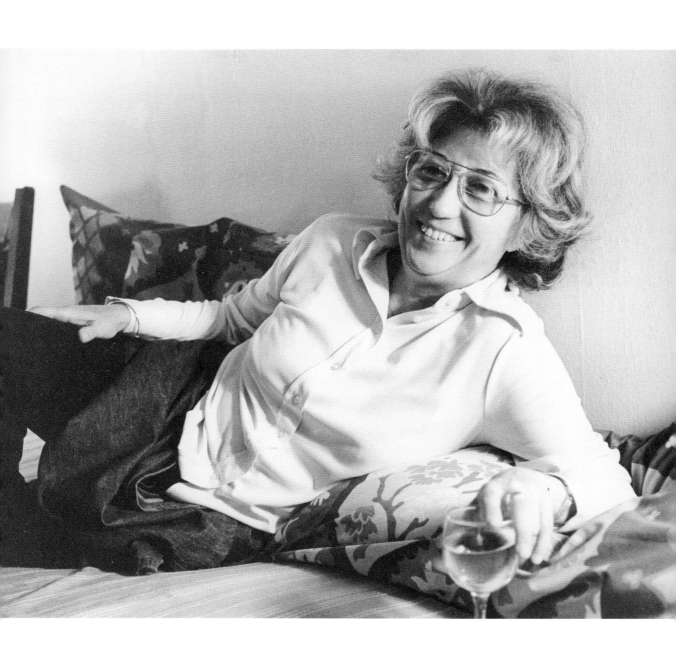

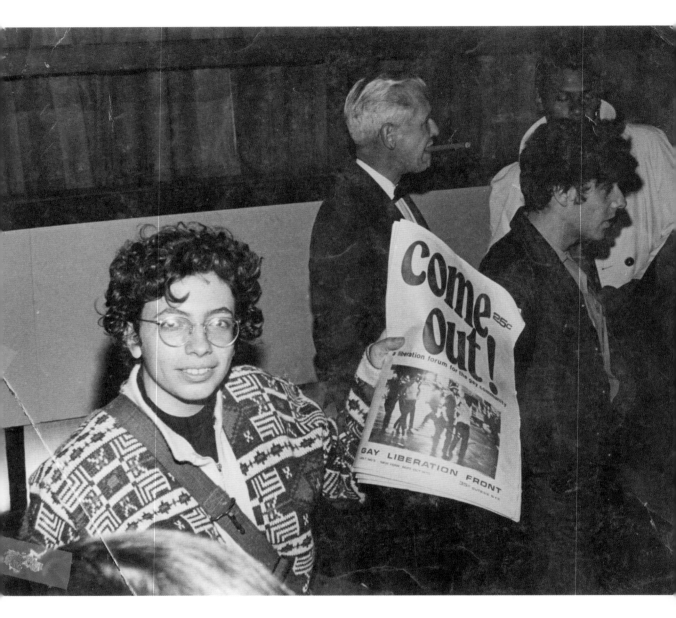

Martha Shelley selling GLF's newspaper *Come Out!* during a demonstration at New York University's Weinstein Hall. Shelley is an activist and writer who worked with the Daughters of Bilitis, the Student Homophile League, the Gay Liberation Front, and the Lavender Menace, among many others.

*Diana Davies, 1970.*

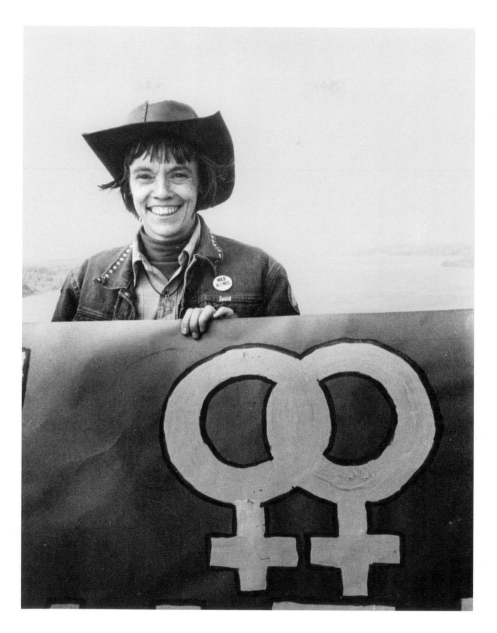

Kady Van Deurs at a "hold hands" demonstration. Van Deurs was a feminist and peace activist. She is the author of *The Notebooks That Emma Gave Me: The Autobiography of a Lesbian* (1978) and *Panhandling Papers* (1989).

*Diana Davies, 1973.*

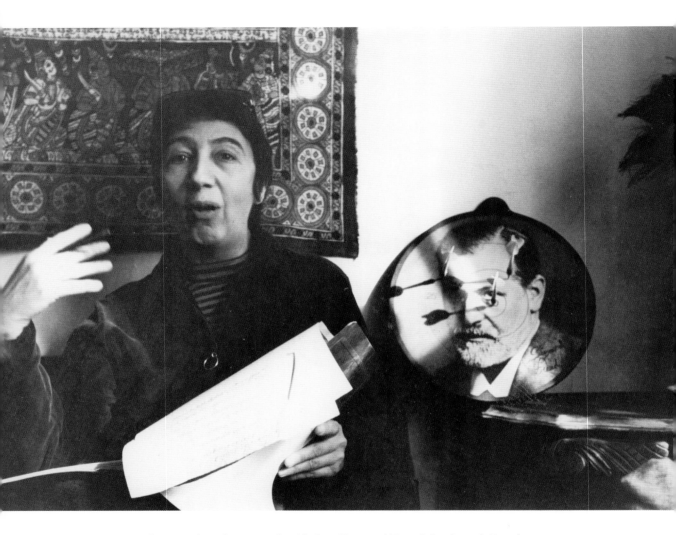

Rosalyn Regelson lecturing beside her Sigmund Freud dartboard. Regelson was a film and theater critic and taught one of the first positive academic courses about homosexuality in the United States, at New York University in 1969.

*Kay Tobin Lahusen, 1971.*

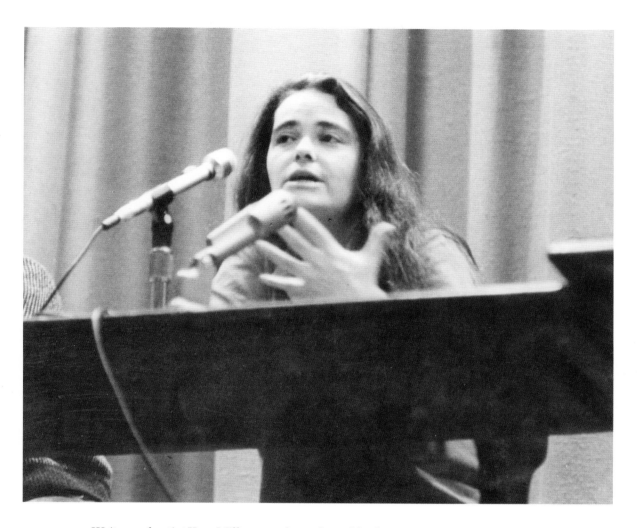

Writer and artist Kate Millett was the author of the feminist classic *Sexual Politics,* published in 1970, and many other works. Millet is pictured here speaking at a panel on sexuality at Columbia University at which she publicly came out as bisexual.

*Diana Davies, 1970.*

Kay Whitlock standing on Camac Street, a historically queer street in Philadelphia. Whitlock is a writer and activist who worked with the National Gay Task Force and the National Organization for Women. She is coauthor of *Considering Hate: Violence, Goodness, and Justice in American Culture and Politics* and *Queer (In)Justice: The Criminalization of LGBT People in the United States.*

*Kay Tobin Lahusen, 1977.*

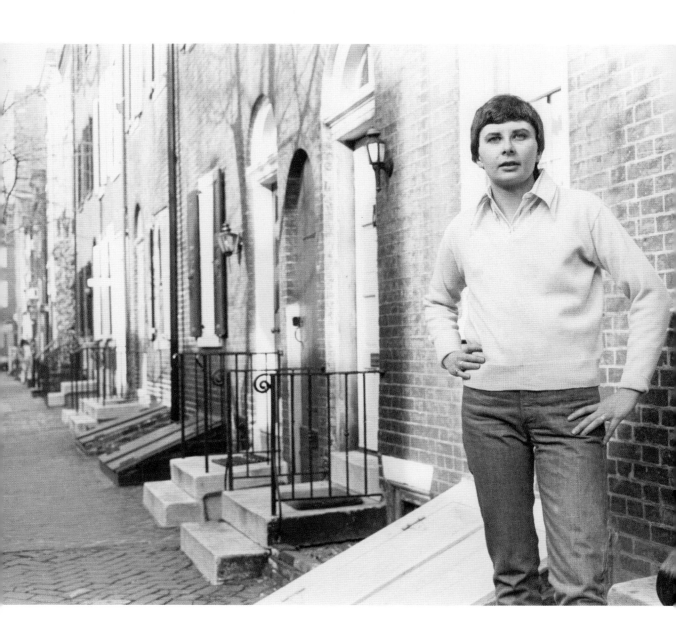

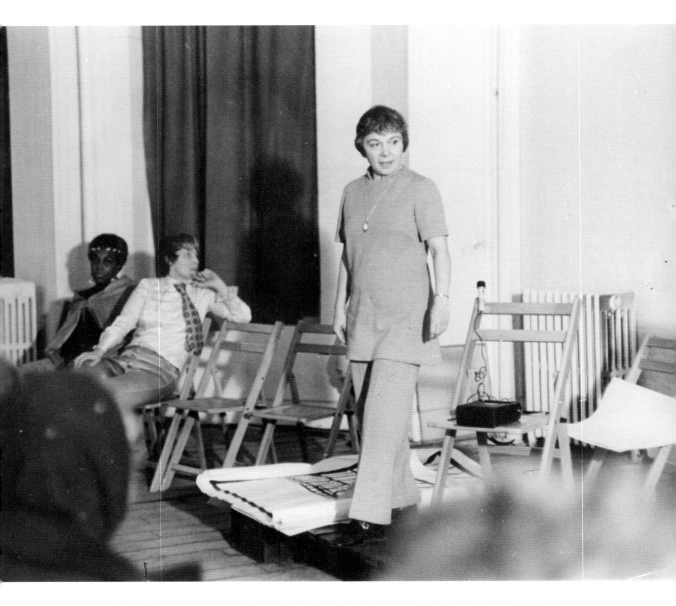

Ruth Simpson was president of the New York chapter of the Daughters of Bilitis in the early 1970s and was instrumental in their opening the first lesbian community center, where this picture was taken, in 1971. She was also the author of *From the Closet to the Courts: The Lesbian Transition* (1976).

*Diana Davies, 1971.*

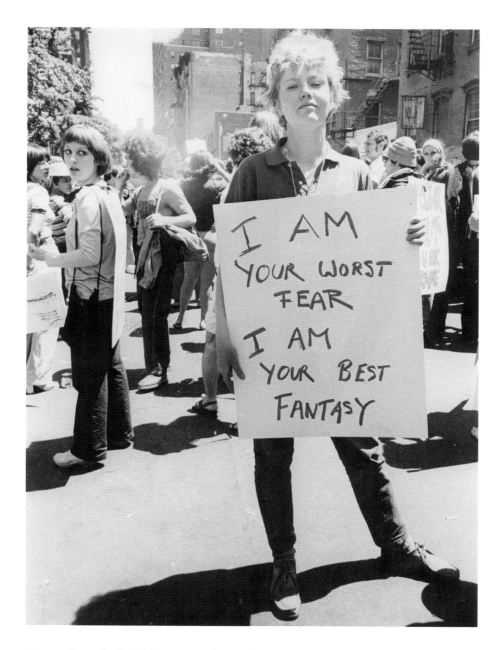

Donna Gottschalk holding a sign that reads, "I am your worst fear / I am your best fantasy" at Christopher Street Liberation Day march in 1970. Gottschalk is a photographer who was active with the Gay Liberation Front and the Radicalesbians.

*Diana Davies, 1970.*

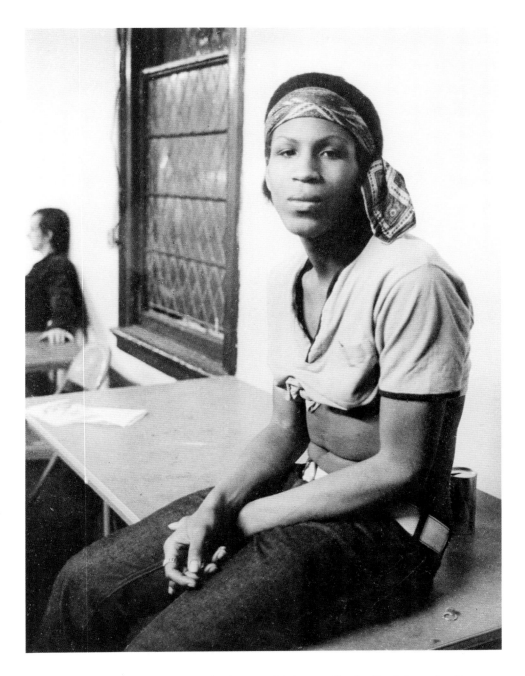

Zazu Nova was a participant in the Stonewall Riots and in the Gay Liberation Front.

*Diana Davies, 1969.*

# LOVE

One of the most striking themes in these photographs is intimacy. From her first photos for *The Ladder*, Lahusen worked to portray the relationships of same-sex couples with both tenderness and respect. Similarly, Davies captured defiant public displays of affection as moments of both romance and revolution. In order to fully appreciate the acts of resistance in these photographs, we have to consider them in their historical and political context. In an era when sex between people of the same gender was a crime that could be subject to fines or imprisonment in most of the United States, and depictions of those desires could be considered obscene, this was truly groundbreaking. Across the United States in this era, people could be institutionalized as mentally ill for being homosexual. Same-sex couples openly displaying affection could be arrested for disorderly conduct. To capture these moments on film was daring for both photographers and subjects.

Although many of the couples depicted here are lovers, some are intimate friends and comrades in struggle drawn together by their desires, illustrating the popular queer slogan of the era "An army of lovers cannot fail." Inspired by the sexual revolution that was sweeping the country, the LGBTQ people of the 1960s and '70s were questioning the full range of possibilities regarding love, sexuality, and friendship. They experimented with open relationships, polyamory, communal living, erotic friendships, and cruising, and they even fought for the right to traditional legal marriage. They embraced the radical idea that sexual desire and love could be grounds for totally transforming society.

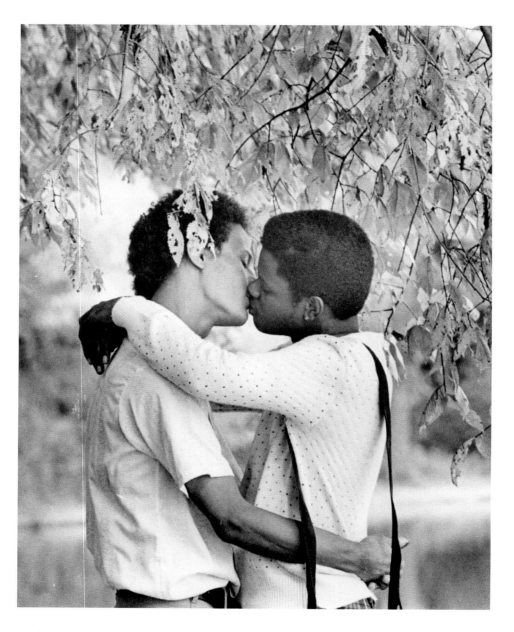

This image of a couple kissing under a tree was taken at the 1977 Integrity Conference in Philadelphia.

*Kay Tobin Lahusen, 1977.*

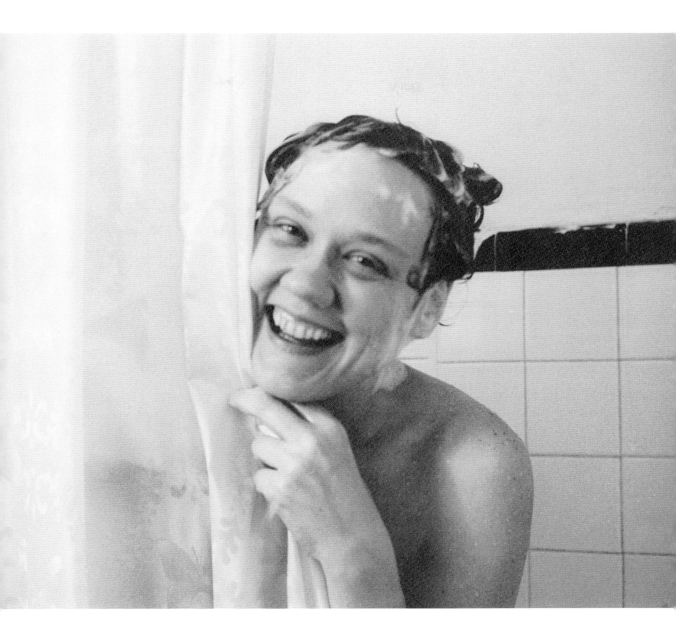

Lahusen's archive of photographs of her partner, Barbara Gittings, includes professional portraits and documentation of her activism, as well as many candid photographs—like this image of Gittings in the shower—that capture the intimate moments of their lives together.

*Kay Tobin Lahusen, 1962.*

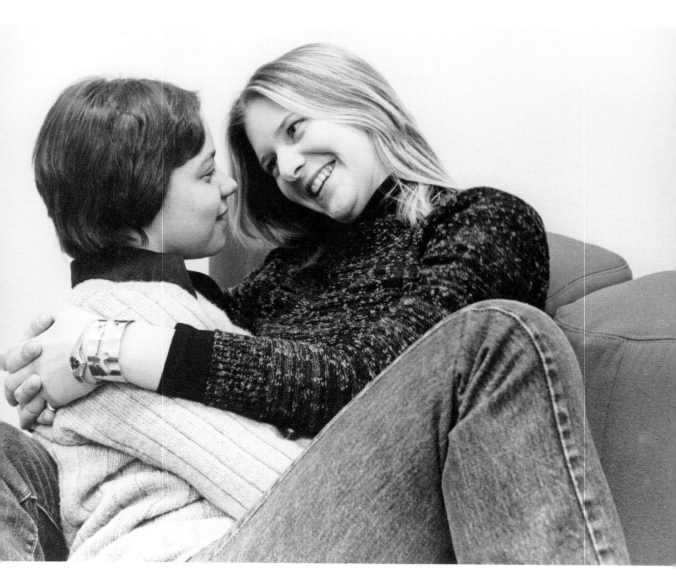

This photograph is from a series that Lahusen took in the late 1970s documenting lesbian couples.

*Kay Tobin Lahusen, 1977.*

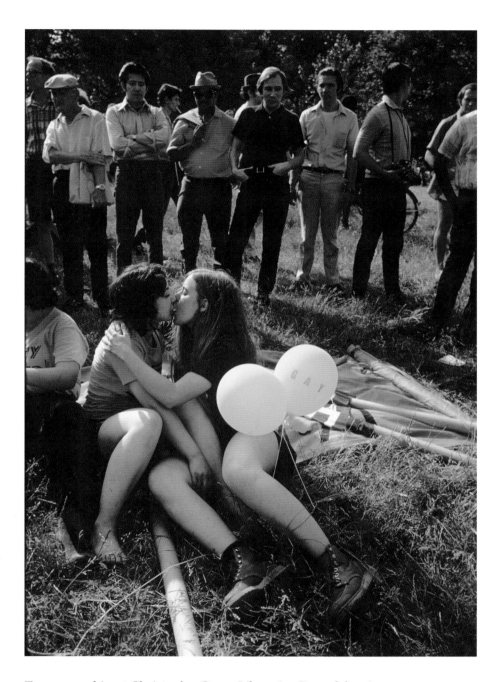

Two women kiss at Christopher Street Liberation Day celebration.

*Diana Davies, 1971.*

Nancy Tucker (left) and partner march in coordinating "Butch" and "Femme" T-shirts at Christopher Street Liberation Day 1970. Tucker is an activist and writer who was part of the Mattachine Society of Washington, Gay Liberation Front of Washington, D.C., and the Gay Women's Alternative; she also cofounded the District of Columbia's LGBTQ newspaper, *The Gay Blade,* which later became *The Washington Blade.*

*Kay Tobin Lahusen, 1970.*

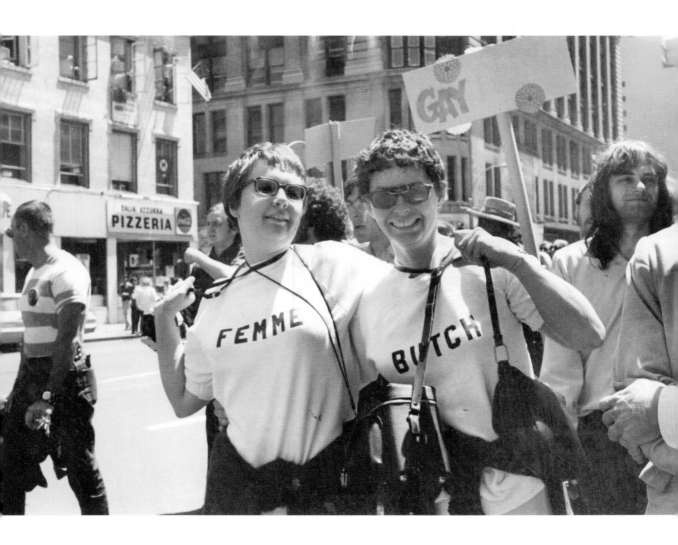

Jack Nichols (left) and Lige Clarke posing together at *Gay*'s offices in New York City. Nichols and Clarke coedited *Gay,* "America's first weekly homosexual newspaper," which began publication in 1970. They also coauthored *I Have More Fun with You than Anybody* (1972) and *Roommates Can't Always Be Lovers* (1974). Nichols was a cofounder of the Mattachine Society of Washington and the Mattachine Society of Florida, and Clarke was active with the Mattachine Society of New York, as well as the Mattachine Society of Washington.

*Kay Tobin Lahusen, 1971.*

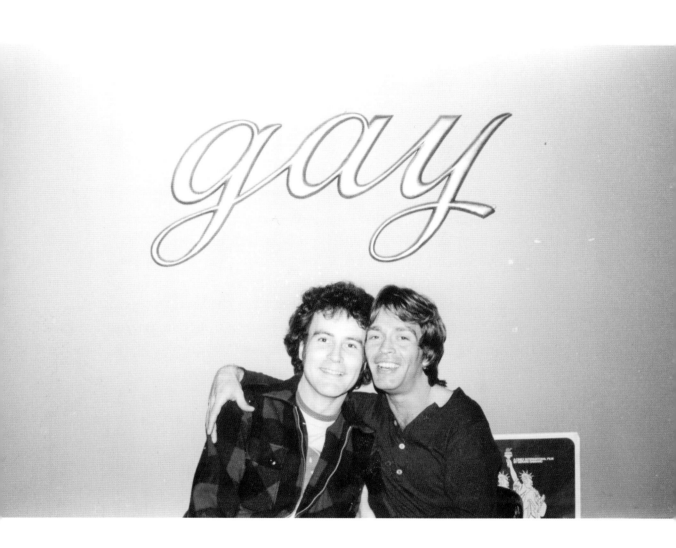

Marty Robinson (left) and Tom Doerr embrace during the Gay Activists Alliance's sit-in at the Republican State Committee on June 24, 1970, to demand that New York governor Nelson Rockefeller address the demands of the gay community. Doerr was a cofounder of the Gay Activists Alliance and designed their lambda logo, which became a major symbol of gay liberation in the 1970s. Robinson participated in the Stonewall Riots and cofounded GAA, the Lavender Hill Mob, the National Gay Task Force, and the Gay and Lesbian Alliance Against Defamation (GLAAD).

*Diana Davies, 1970.*

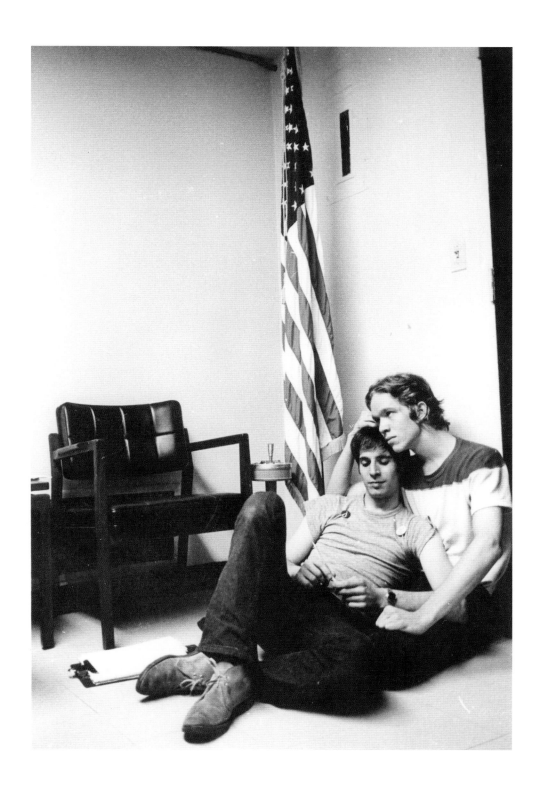

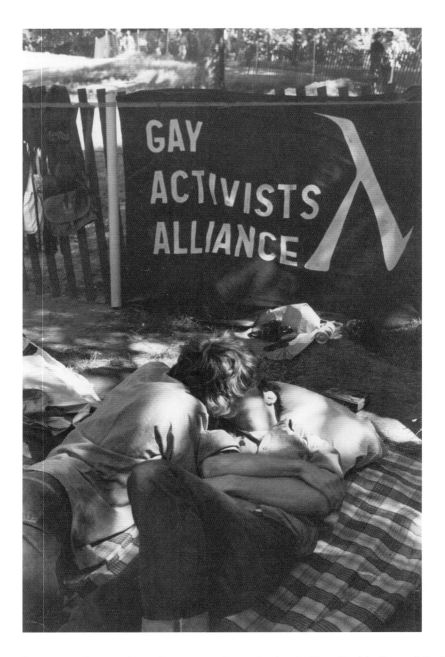

Men kissing at the "gay be-in happening," a gathering in New York's Central Park at the end of Christopher Street Liberation Day, the first LGBTQ pride march, in June 1970.

*Kay Tobin Lahusen, 1970.*

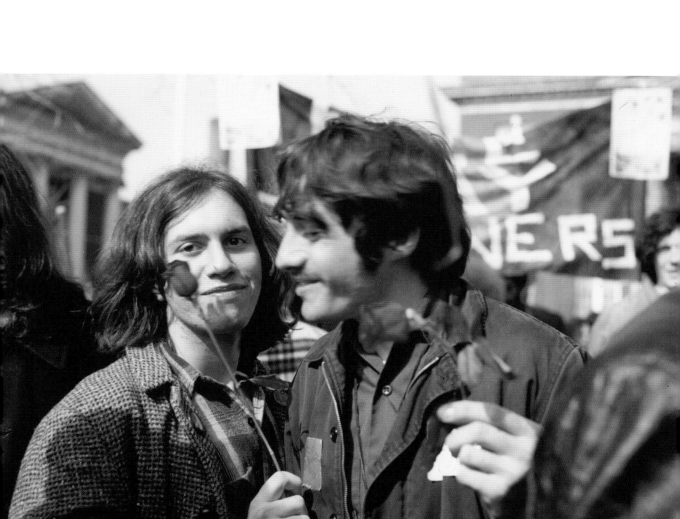

Two men hold roses at a gay rights demonstration in Albany, New York.

*Diana Davies, 1971.*

Michael McConnell (left) and Jack Baker were among the first couples to fight for marriage equality in the United States when they applied for a marriage license in Minneapolis in 1970. They managed to obtain a license in another Minnesota county in 1971, and were married later that year. When government agencies refused to acknowledge their marriage, they took their case to the U.S. Supreme Court in *Baker v. Nelson* in 1972, where the appeal was dismissed in 1972. That precedent would not be explicitly overruled until *Obergefell v. Hodges* made same-sex marriage legal nationwide in 2015. McConnell and Baker are still married.

*Kay Tobin Lahusen, 1970.*

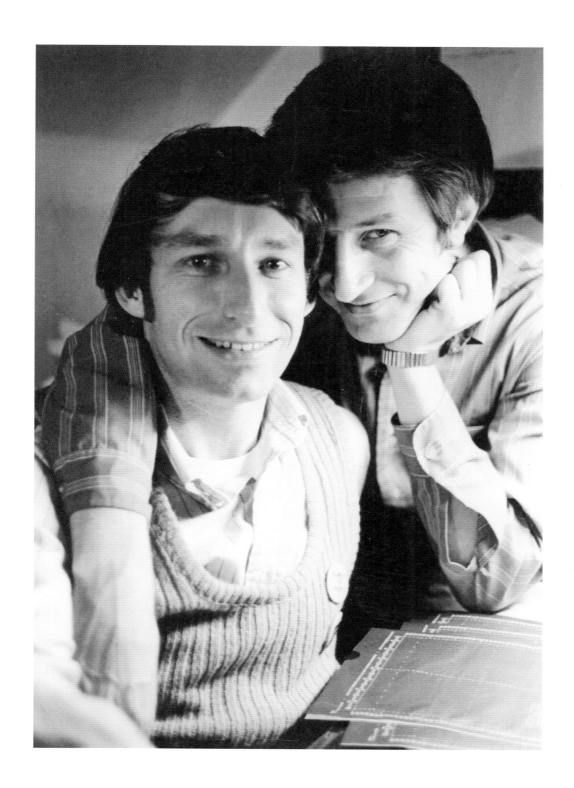

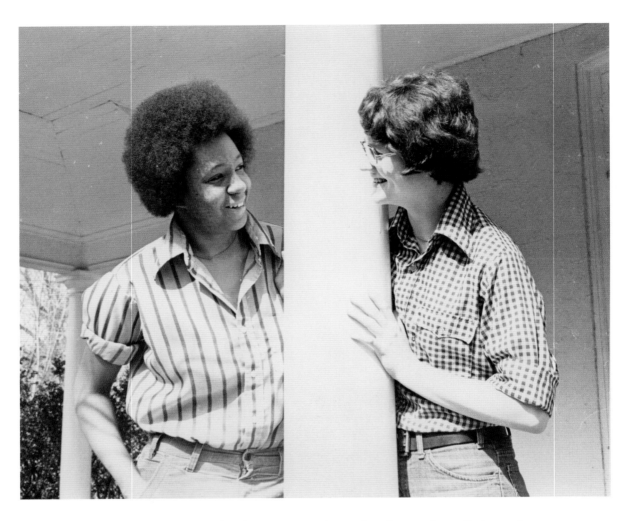

Lahusen documented this Germantown, Pennsylvania, couple on their porch as part of her series on gay and lesbian couples in the late 1970s.

*Kay Tobin Lahusen, 1977.*

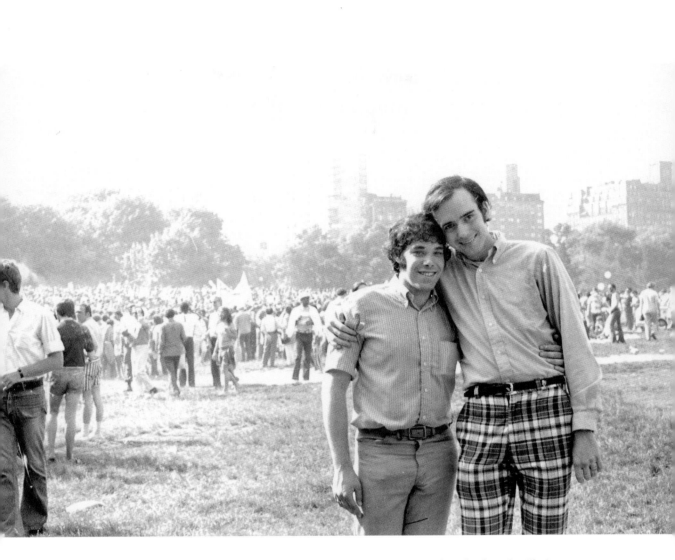

A gay couple hugs in the Sheep Meadow of New York's Central Park after the Christopher Street Liberation Day march. Ending the march in the park allowed marchers to easily gather with friends and lovers.

*Kay Tobin Lahusen, 1971.*

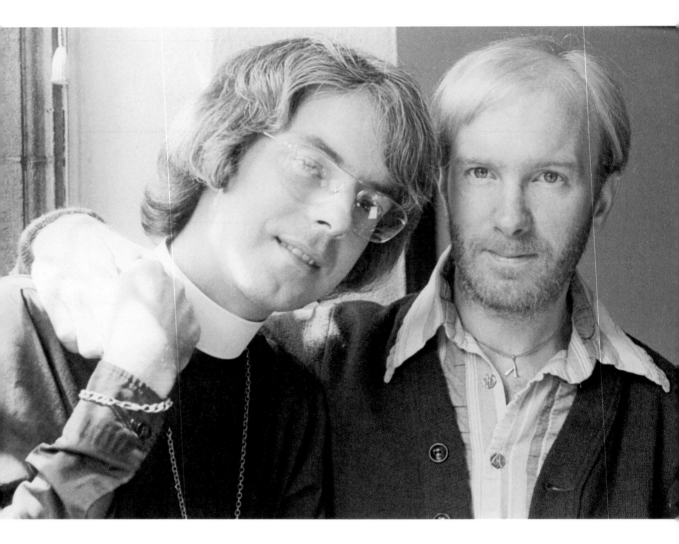

This photograph of John Lenhart (left) and a man named Gary (right) is one of many images by Lahusen that documented LGBTQ Episcopalians in the 1970s.

*Kay Tobin Lahusen, 1975.*

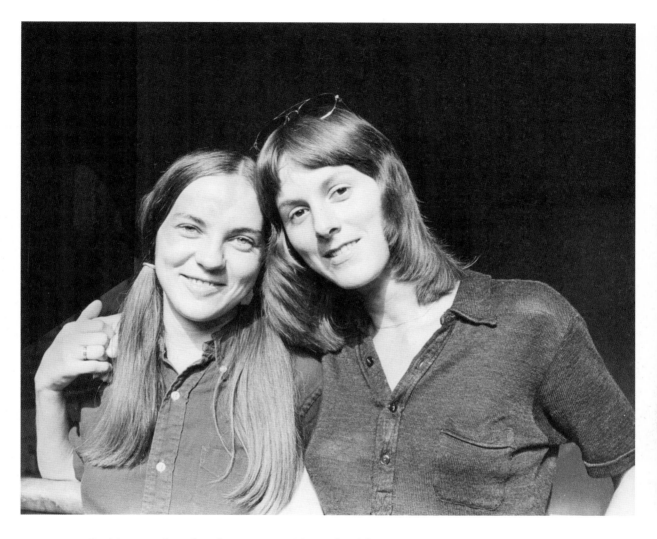

Lesbian couple embracing at a gay pride week celebration held by the Community Homophile Association of Toronto, Ontario.

*Kay Tobin Lahusen, 1972.*

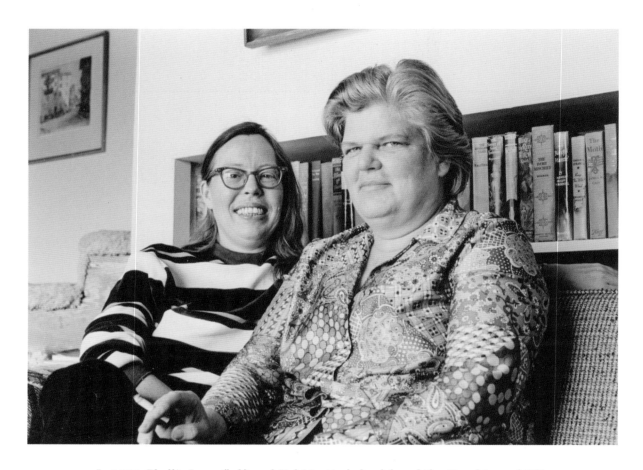

In 1955, Phyllis Lyon (left) and Del Martin helped found the Daughters of Bilitis in San Francisco, as well as the organization's magazine, *The Ladder*, beginning a lifetime of political activism. They were partners from 1953 until Martin's death in 2008.

*Kay Tobin Lahusen, 1970.*

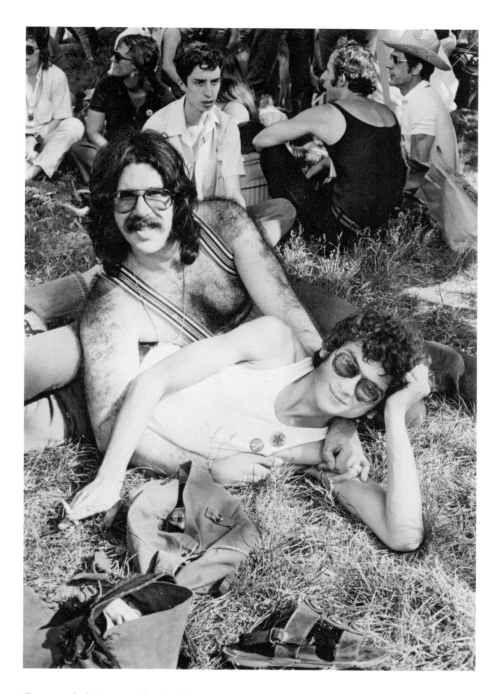

Gay couple lying together in the grass in Central Park after Christopher Street Liberation Day.

*Kay Tobin Lahusen, 1971.*

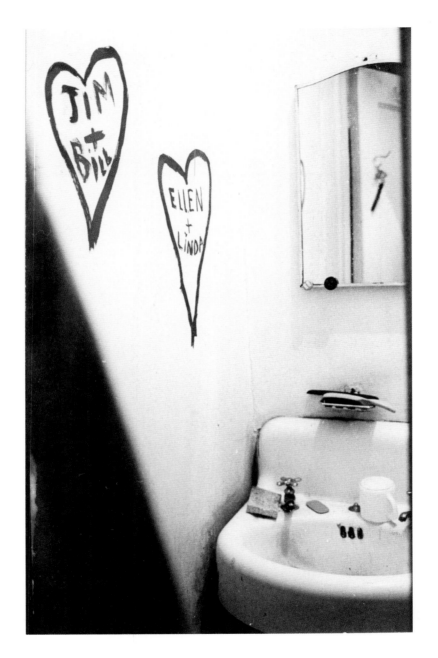

The graffiti on the restroom wall at the Oscar Wilde Memorial Bookshop had hearts drawn around two pairs of names: "Jim & Bill" and "Ellen & Linda."

*Diana Davies, 1969.*

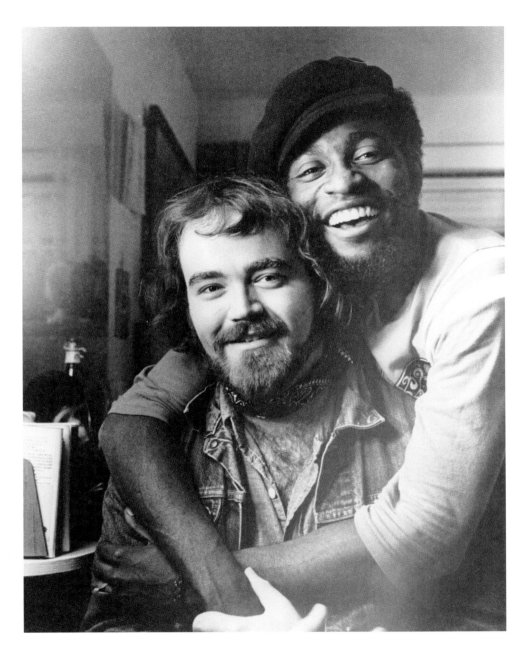

John Powell hugging George Burke. Powell, who was known as "Sagittarius" or "Saj," was a gay liberation activist and musician active in Philadelphia in the 1970s.

*Kay Tobin Lahusen, 1972.*

Barbara Deming (left) was an author as well as a civil rights, peace, and feminist activist. She wrote more than nine books, including *Prison Notes* (1966), *We Cannot Live Without Our Lives* (1974), and *A Humming under My Feet* (1985). Beatrice Hawley (right) was a poet who published the collections *Making the House Fall Down* (1977) and *Nothing Is Lost* (1979).

*Diana Davies, 1976.*

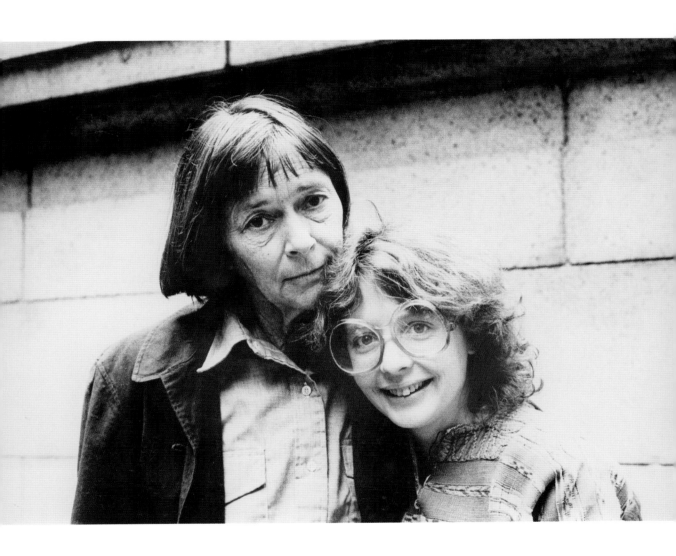

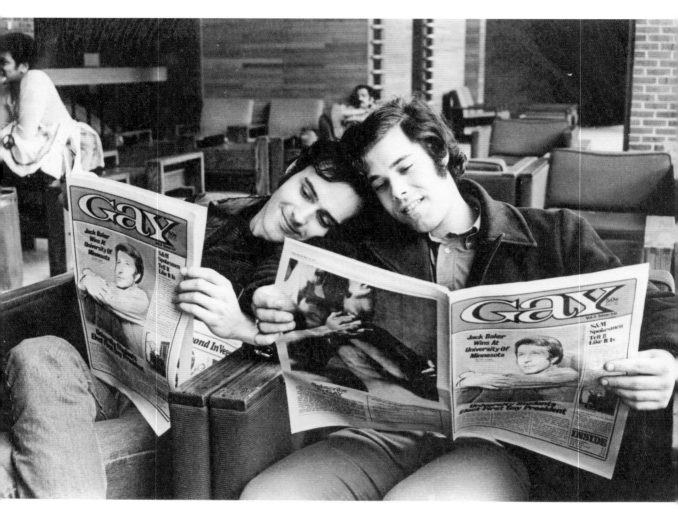

In this promotional photograph for *Gay*, two men cuddle while reading the newspaper.

*Kay Tobin Lahusen, 1971.*

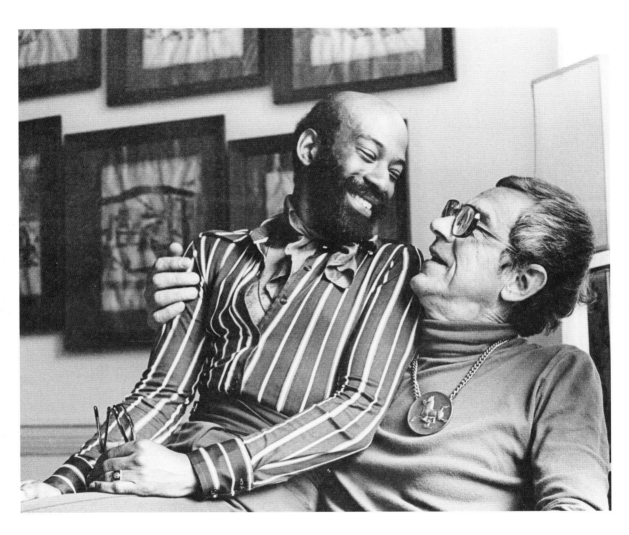

Jamen Butler (left) and Tom Malim were supporters of the Gay and Lesbian Community Center of Philadelphia, now known as the William Way Center.

*Kay Tobin Lahusen, 1971.*

A lesbian couple attending the National Student Association (NSA) meeting in Washington, D.C., in 1972. The NSA had formed a so-called gay desk the previous year to support LGBTQ student associations across the country, establish a speakers bureau, and help develop LGBTQ curricula.

*Kay Tobin Lahusen, 1972.*

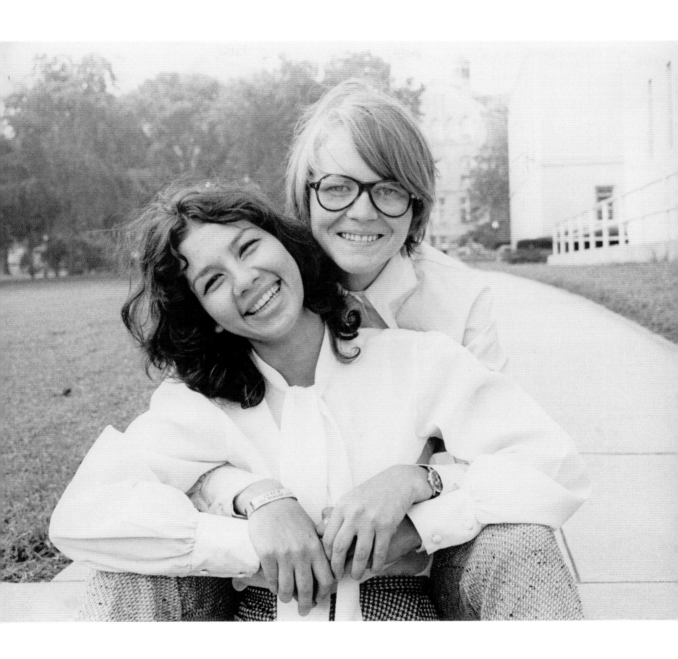

# PRIDE

L GBTQ resistance involved more than just protesting and coming out of the closet. It also required creating alternatives to straight and cisgender cultures and institutions. In the 1960s, there were straight bars that would display signs saying, "Faggots stay out" or "If you are gay, please stay away." Bars could be shut down if they served known homosexuals, and people could be arrested for wearing clothing that did not conform to their legally assigned gender.

Not only were LGBTQ people unable to be fully themselves in straight, cisgender communities, many LGBTQ activists sought to challenge the monopoly these communities had on public life. In this era, gay, lesbian, bisexual, and transgender activists began to create alternative public forums where they could meet, not just for socializing, but also to discuss their cultural and political situation, through organizations like the Mattachine Society and the Daughters of Bilitis. Later, they worked to establish collective public institutions with the emergence of LGBTQ community centers. Of course, they were also looking for safe spaces to meet for friendship, self-expression, and love. These spaces included vital alternatives to the gay and lesbian bars of the time, which were regular sites of police entrapment and often controlled by the mafia.

With the annual "reminder" marches in Philadelphia starting in the mid-

1960s and the Christopher Street Liberation Day marches and gay be-ins in the 1970s, activists went further by boldly reclaiming public space in broad daylight. And, through the creation of a network of national journals and newspapers from *The Ladder* to *The Advocate* and *Gay,* LGBTQ people developed their own intellectual forums to parallel the physical spaces that they were opening up. They resisted their exclusion from and condemnation by society by creating their own spaces where they could communicate, dance, dream, scheme, and love, beginning the tradition of being "out and proud."

In June 1969, the Stonewall Inn was the site of famous riots that changed LGBTQ activism and American culture. The Stonewall Riots were not the first time that gays, lesbians, bisexual and transgender people had protested or fought back against police—they were preceded by the Compton's Cafeteria riot in San Francisco in 1966 and the protests after police raids at the Black Cat Tavern in Los Angeles in 1967, among others—but they were a turning point in LGBTQ political consciousness. They sparked a convergence of homophile activism with the energy of the counterculture that transformed the way that LGBTQ people understood themselves and the world.

*Diana Davies, 1969.*

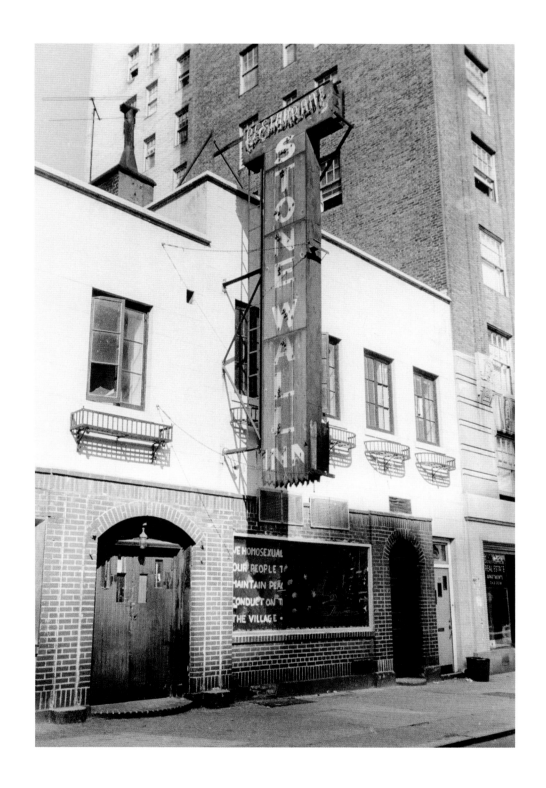

The Gay Liberation Front marches on Times Square, New York City. In the wake of the Stonewall Riots, the GLF formed, bringing a new generation of people into gay and lesbian political activism that had been growing throughout the 1960s. This generation was informed by a different constellation of influences, from the peace and student movements, the counterculture, and the examples of the Black Panthers and various third-world liberation movements. GLF was like a crucible that incubated many other movements for gay, lesbian, bisexual, and transgender liberation.

*Diana Davies, 1969.*

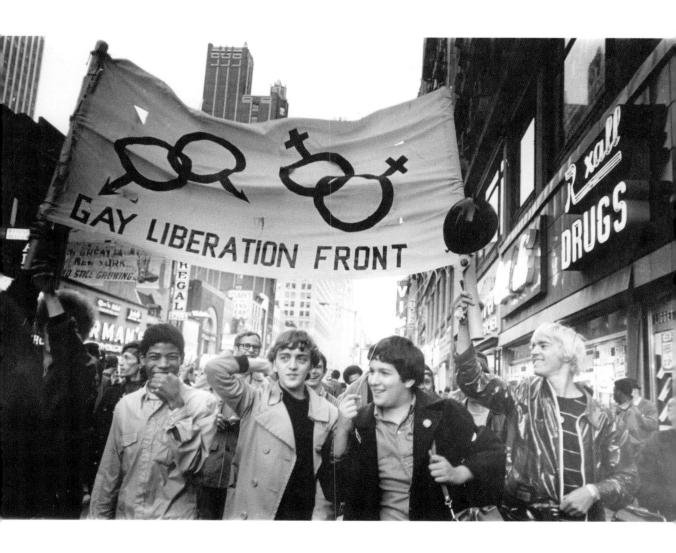

The Gay Liberation Front preparing for their dance at Alternate University, in downtown New York. In addition to political activism and consciousness-raising, GLF also held dances. These events helped raise money and cultivate community for the organization and its causes. They also provided an alternative to LGBTQ bars, which were often controlled by organized crime. The dances enabled GLF to create alternative cultural spaces that were by and for the community.

*Diana Davies, 1970.*

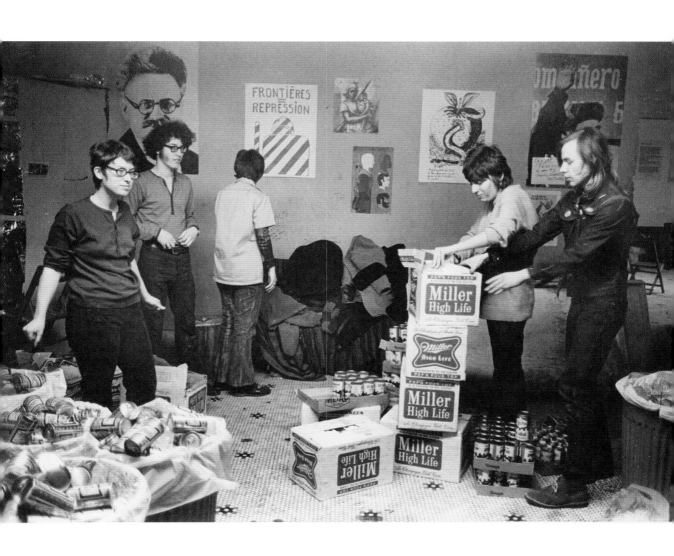

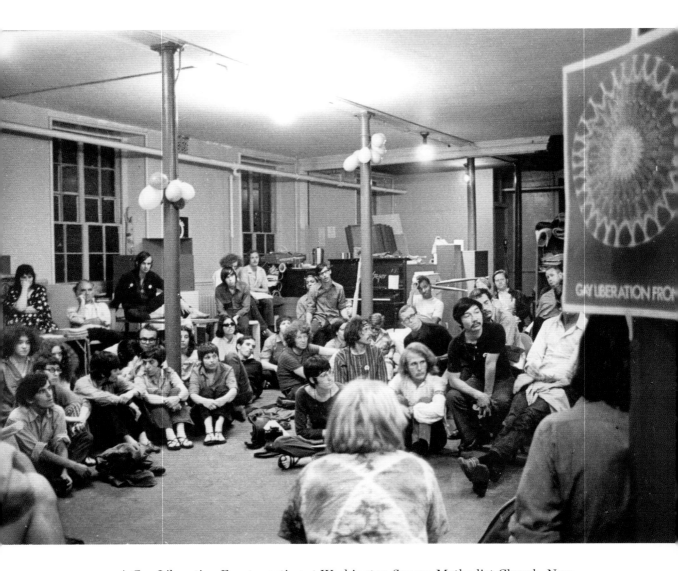

A Gay Liberation Front meeting at Washington Square Methodist Church, New York. Perhaps surprisingly, several churches in 1970s New York often made their spaces available for meetings of the emerging gay and lesbian liberation organizations.

*Diana Davies, 1970.*

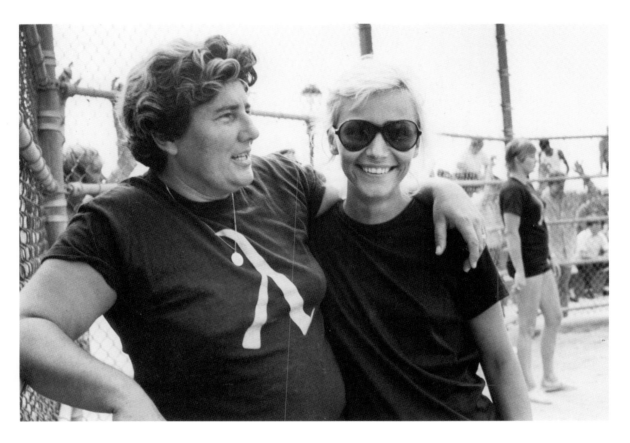

In addition to political demonstrations, GAA also sponsored a range of social events, including a softball team, members of which are depicted here in August 1970. The photograph ran in *Gay* with the caption "Is Shea Stadium ready for our team?"

*Kay Tobin Lahusen, 1970.*

Gay Activists Alliance opened their community center in a converted firehouse in the emerging Soho neighborhood of New York in 1971. It functioned as headquarters for their meetings, programs, and dances until it was burned by arsonists in 1974. The Firehouse fulfilled a long-standing desire for a meaningful community space, serving not just GAA but many other organizations.

*Diana Davies, 1971.*

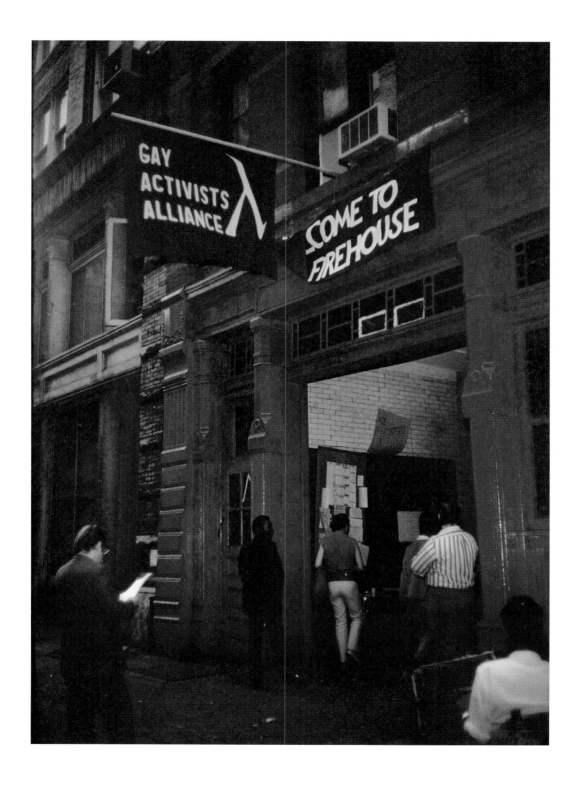

Feminist author and activist Betty Friedan warned members of the National Organization for Women (NOW) in 1969 of the "lavender menace" of lesbians threatening to corrupt and derail the women's movement and moved to purge lesbians from leadership positions in the organization. In protest, a group of Gay Liberation Front women, who became known as the Radicalesbians, decided to disrupt NOW's Second Congress to Unite Women in May 1970. They crashed the conference wearing T-shirts emblazoned with "Lavender Menace" and distributed copies of a manifesto called "The Woman-Identified Woman." The action turned the course of the feminist movement, and NOW adopted a resolution affirming commitment to lesbian political concerns the following year. At far right, in a "Lavender Menace" t-shirt, is writer and activist Rita Mae Brown.

*Diana Davies, 1970.*

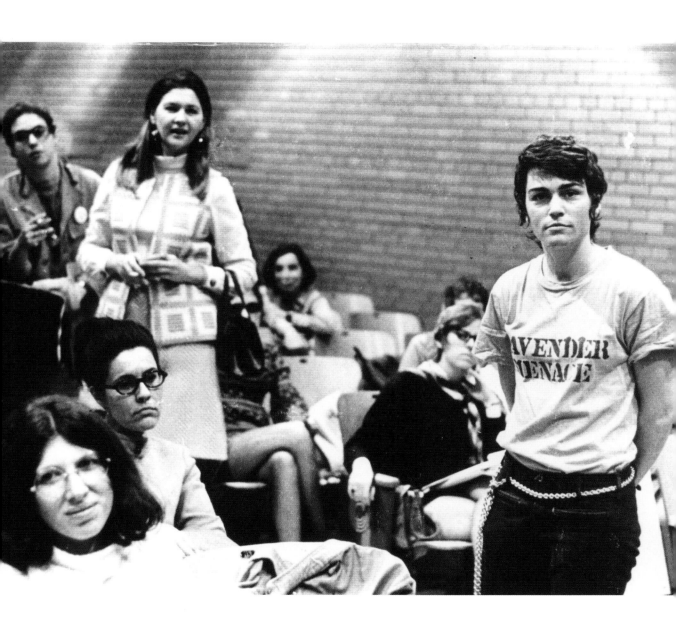

Frank Kameny and Mattachine Society of Washington members marching in the 1970 Christopher Street Liberation Day demonstration, with a "Gay Is Good" sign. There was tremendous overlap between the activist movements of the 1960s and '70s. Veteran activists like Kameny came into their prime with the massive expansion of political consciousness in gay and lesbian communities.

*Kay Tobin Lahusen, 1970.*

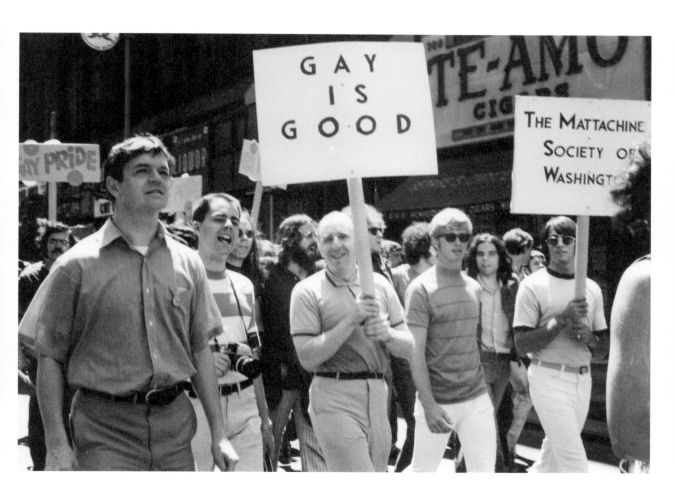

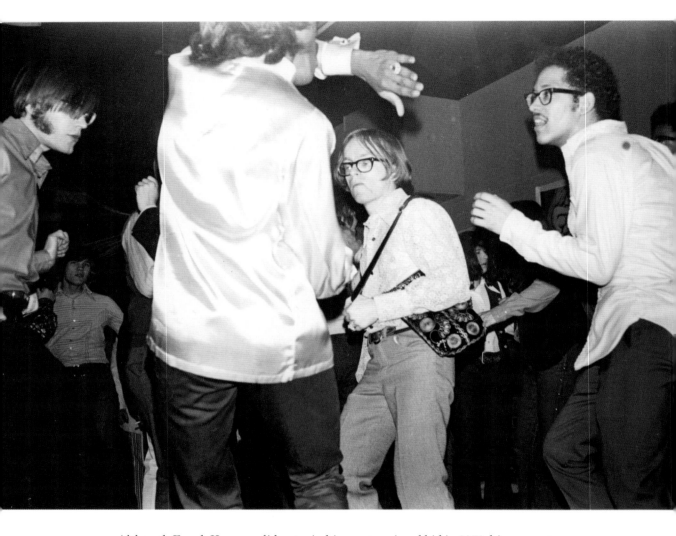

Although Frank Kameny did not win his congressional bid in 1971, his supporters still had plenty to celebrate. It was the first time an openly gay candidate had run for Congress, and it would not be the last.

*Kay Tobin Lahusen, 1971.*

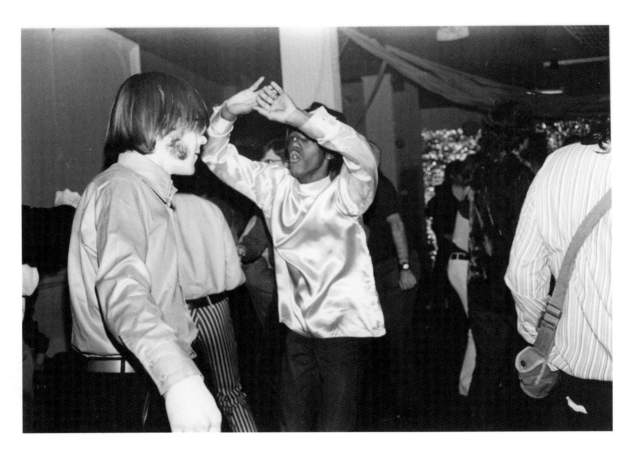

Supporters dance at the Frank Kameny campaign afterparty.

*Kay Tobin Lahusen, 1971.*

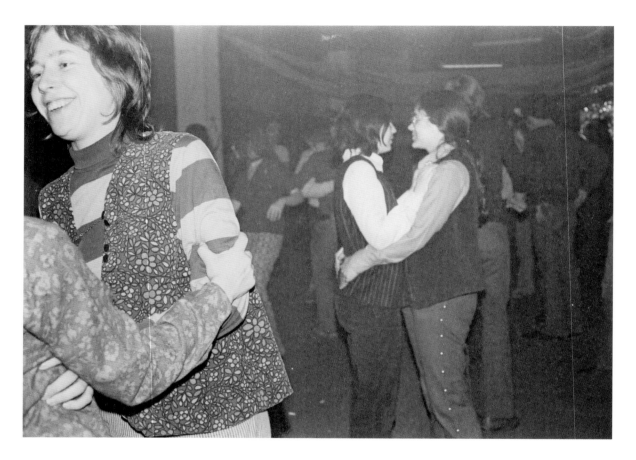

Women dancing at Frank Kameny congressional campaign celebration.

*Kay Tobin Lahusen, 1971.*

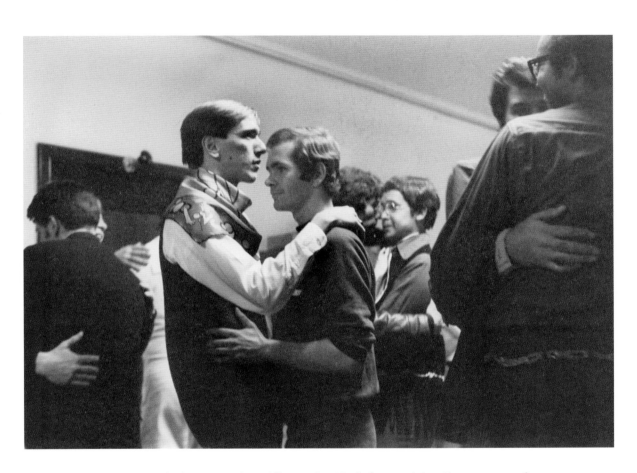

Men dancing before a march on Albany, New York, for gay rights. Dances were often integrated with political events, both as opportunities to meet and as fund-raisers to support LGBTQ organizations and causes.

*Kay Tobin Lahusen, 1971.*

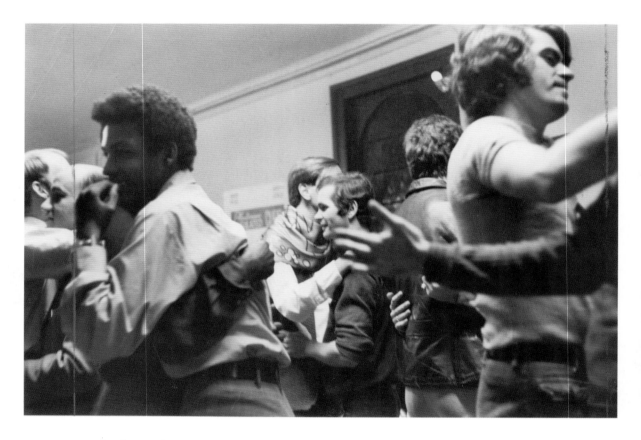

The dance the evening before the first Albany march was held in a church and promised a "rock band and go-go dancers."

*Kay Tobin Lahusen, 1971.*

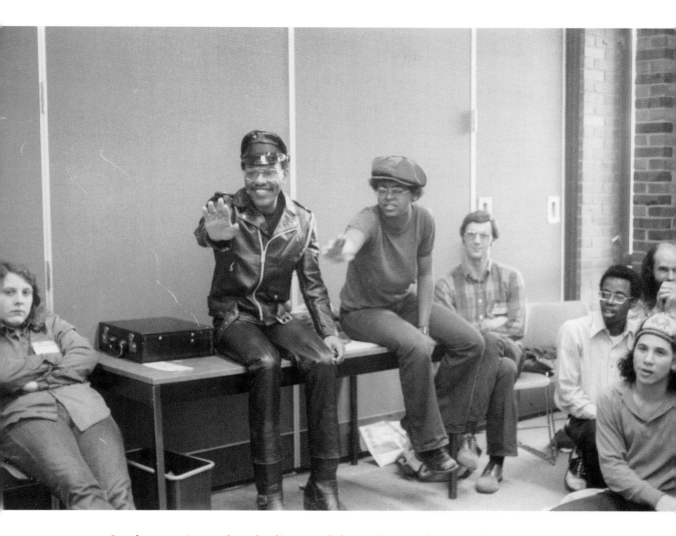

Leather-wearing students leading a workshop at Rutgers' first Gay Liberation Conference, organized by the Rutgers University Homophile League. LGBTQ campus groups sprang up across the country with the spread of gay liberation movements.

*Kay Tobin Lahusen, 1971.*

Gay patrons defend Christopher's End bar in New York during a protest by gay activists. Like today, LGBTQ communities of the 1970s were seldom in consensus on tactics and goals. There were often clashes of opinions among activists and within the larger LGBTQ community. This picture captures a counterprotest by a group of bar patrons in favor of Christopher's End and its owner, Mike Umbers, as GAA members on the other side of the police line (not shown) protested the bar's connections to organized crime.

*Diana Davies, 1971.*

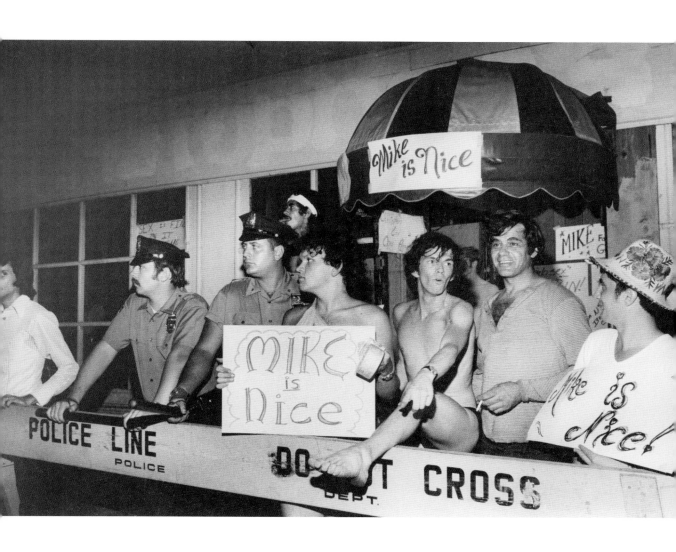

The exterior of the Stonewall Inn as it appeared in September 1969, then closed and up for rent. The sign in the window reads, "We homosexuals plead with our people to please help maintain peaceful and quiet conduct on the streets of the village— Mattachine." The sign was written by Mattachine members who disagreed with the rioting. Not all homophile activists welcomed the explosion of activist energy unleashed with Stonewall.

*Diana Davies, 1969.*

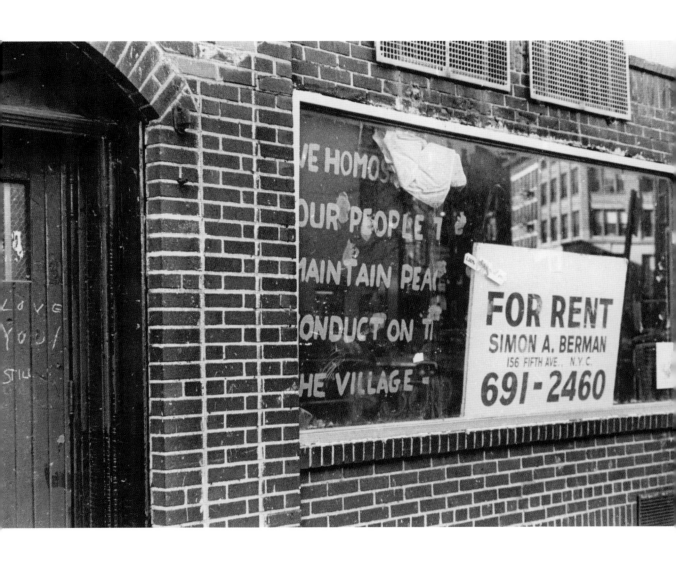

This photograph ran in *Gay* with the caption "A real lesbian meets political lesbians." With the emergence of radical feminism in the 1970s, lesbianism came to be understood not just as a sexual orientation, but as a political stance against patriarchy. This evolution was not necessarily always embraced by those for whom being a lesbian was a frank matter of sexual desire. In this picture, Lahusen captures a discussion between students who identify as lesbians as a political stance and a lesbian activist.

*Kay Tobin Lahusen, 1971.*

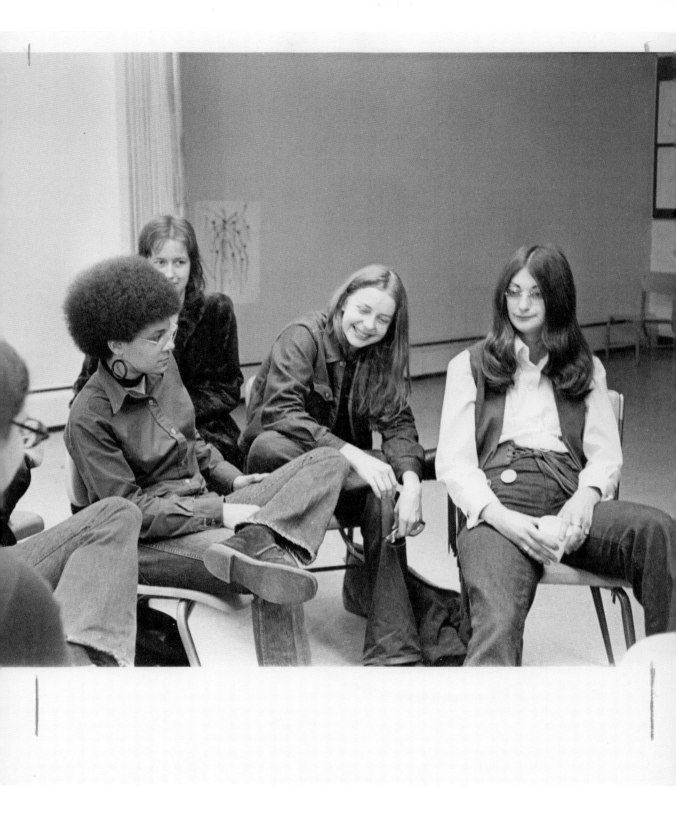

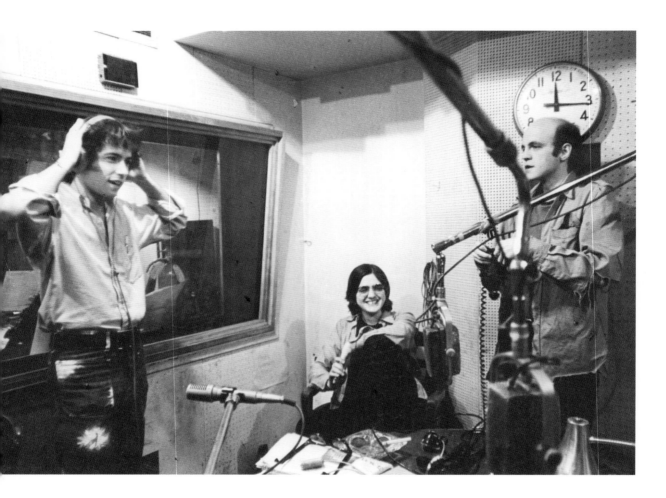

In addition to creating a vibrant print culture, LGBTQ activists in the 1970s took to the air on radio. The leftist, member-supported station WBAI was pioneering in this regard, hosting a show called *Homosexual News*, which began in 1970 and led to decades of innovative radio programming for New York's LGBTQ community.

*Diana Davies, 1970.*

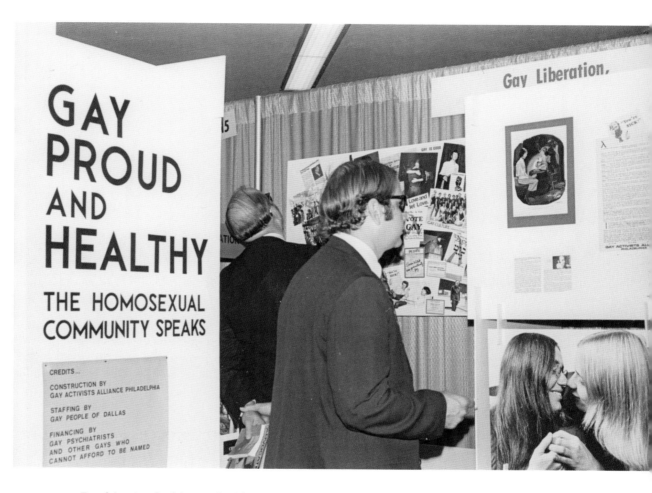

Psychiatrists looking at the "Gay Proud and Healthy" exhibition at the 1972 American Psychiatric Association conference. In the 1970s, Barbara Gittings widened her activist approach to educate professional organizations. She created exhibitions like this one to expand the consciousness of psychiatrists who assumed that homosexuality was a mental illness.

*Kay Tobin Lahusen, 1972.*

Although the Christopher Street Liberation Day march held in New York City in June 1970 is often thought of as the first pride march, sister events were held that year in Los Angeles, Chicago, and many other cities. Soon pride marches were held across the country. This photo depicts the pride march in Philadelphia in 1972, which was a massive event compared with the annual "reminder" marches that had been held by gay and lesbian activists in Philadelphia in the 1960s.

*Kay Tobin Lahusen, 1972.*

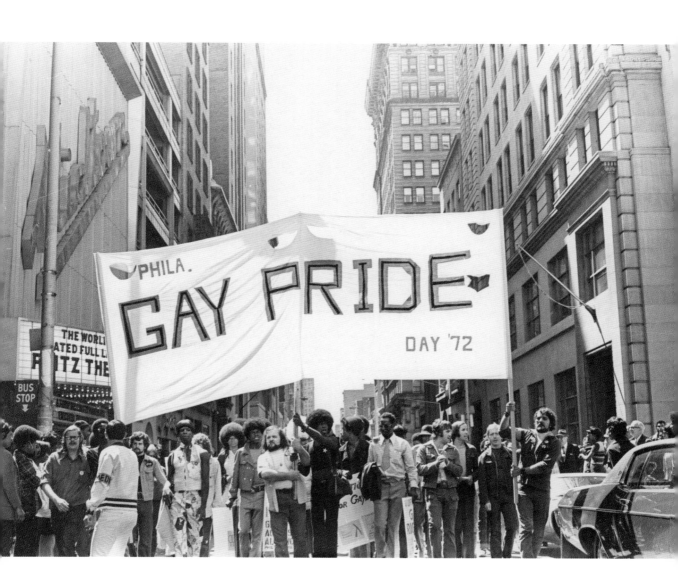

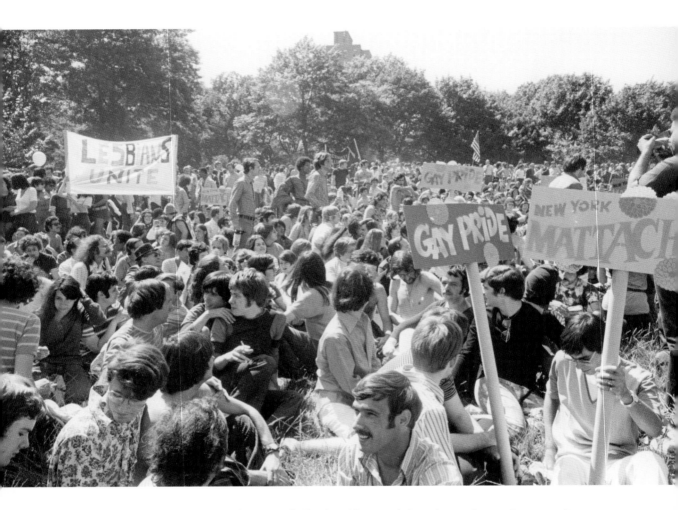

Although the route of New York City's pride march has changed over the years, it originally marched from Christopher Street uptown to Central Park. The early marches ended with a "gay be-in happening" that marked the convergence of LGBTQ activism with the beat and hippie counterculture.

*Diana Davies, 1970.*

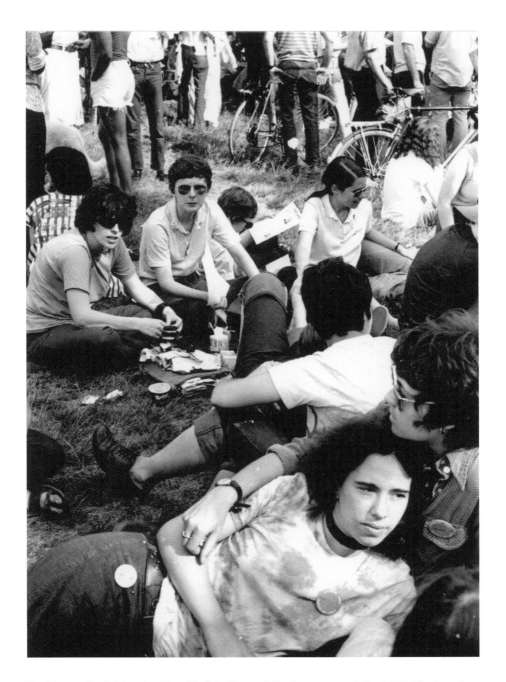

Lesbians picnicking in New York's Central Park as part of the 1971 Christopher Street Liberation Day celebration.

*Kay Tobin Lahusen, 1971.*

A woman carries an "I Enjoy Being a Dyke" sign in the 1971 Christopher Street Liberation Day march. In the post-Stonewall era, LGBTQ people joyfully embraced their sexual orientation in ways that had been unimaginable a decade before.

*Diana Davies, 1971.*

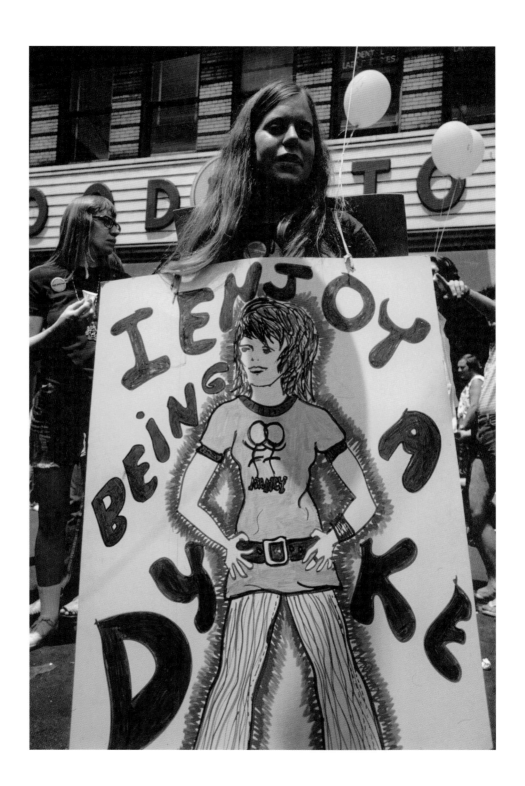

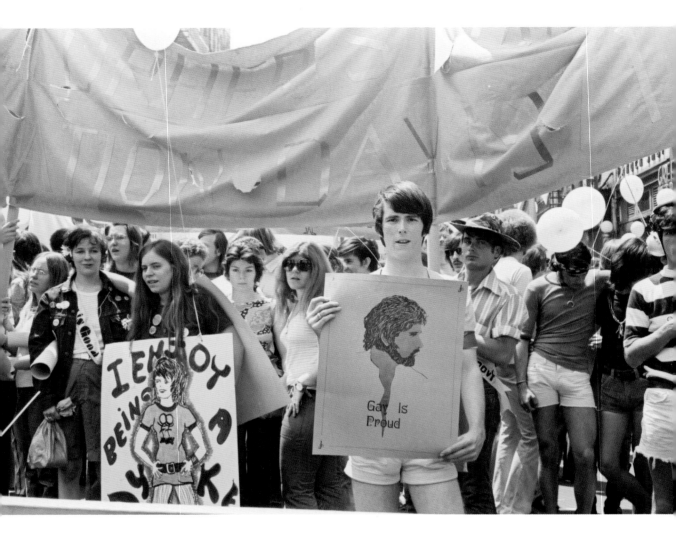

Lahusen captured the same woman with her "I Enjoy Being a Dyke" sign—along with a man holding a "Gay Is Proud" sign—in this photo of marchers gathering for Christopher Street Liberation Day.

*Kay Tobin Lahusen, 1971.*

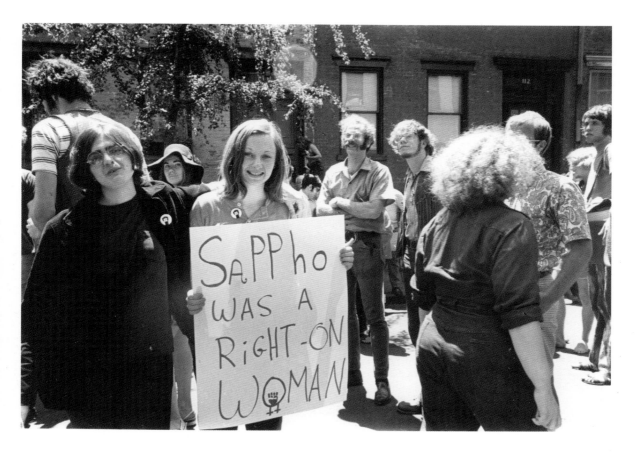

Gay Liberation Front members Judy Cartisano and Stephanie Myers at a demonstration in New York City with a "Sappho Was a Right-On Woman" sign.

*Diana Davies, 1970.*

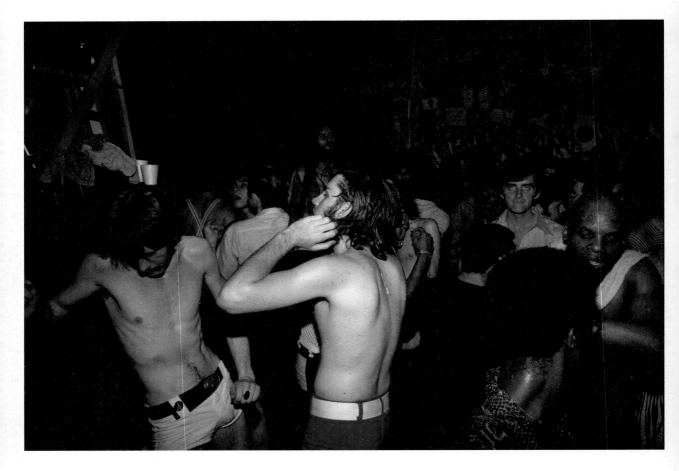

Thousands would attend the weekly Gay Activists Alliance dances, which rivaled the nightclubs and afterhours spots of the day and raised thousands of dollars to support GAA's causes.

*Diana Davies, 1971.*

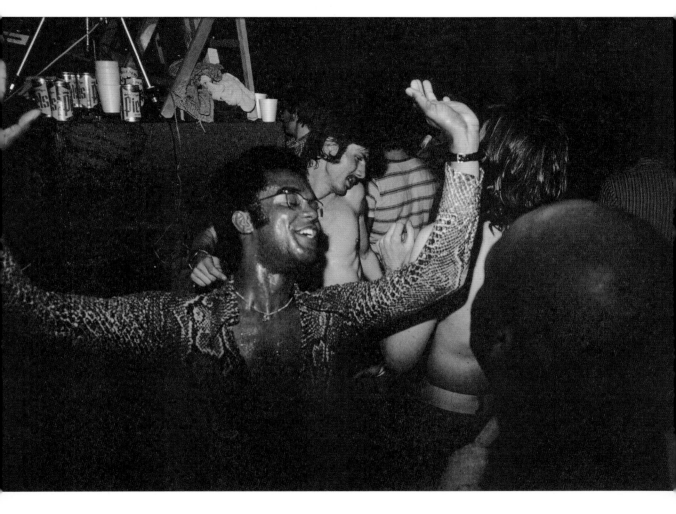

Crowds dancing at the Gay Activist Alliance's Firehouse, 1971.

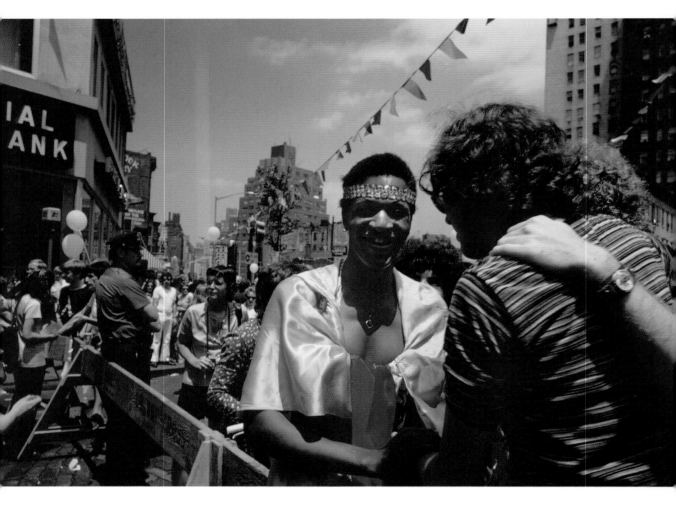

Marsha P. Johnson at Christopher Street Liberation Day, 1971.

*Diana Davies, 1971.*

# PROTEST

T he most recognizable way that these activists resisted their oppression was by picketing and demonstrating. In this, the LGBTQ activists of the 1960s were inspired by the African American civil rights movement; the gay liberation activists of the 1970s were additionally inspired by the antiwar movement, the counterculture, and the movements for liberation around the world occurring at that time.

This series of photographs has been ordered more chronologically to show the evolution of LGBTQ protests during this period. The early homophile-era pickets documented by Lahusen in the 1960s were tightly orchestrated affairs with conservative dress codes—men in business suits and women in sensible skirts in order to seem more palatable—and carefully ordered signs that were attended by a small but brave cadre of devoted activists. Their conservative appearance was part of a strategy that went back to Mattachine founder Harry Hay, who named the organization after masked performers in Renaissance France who critiqued the injustices of the king, nobility, and clergy. Like these masked revelers, homophile activists often hid behind masks of propriety in order to critique their oppression. In contrast, after the Stonewall Riots, LGBTQ marches would attract thousands of participants who felt emboldened to express themselves to the fullest. Still, the Mattachine spirit continued in these post-Stonewall protests as activists used costumes, theater,

and humor to grab media attention and get their points across. Over the decades, LGBTQ protests would grow to involve small media-savvy "zap" protests, artistic and cultural "happenings," interventions in professional meetings, and literally stopping traffic. In this period, LGBTQ political movements developed a range of demonstration tactics that were later used by AIDS activists in the 1980s and '90s and continue to inform activist strategies today.

Ernestine Eckstein (left) marching in a picket line at the White House. In April through October of 1965, the Mattachine Society of Washington, D.C., and associated activists staged a series of pickets of the White House and other government offices and landmarks in protest of the bans on gays and lesbians in federal employment, including military service.

*Kay Tobin Lahusen, 1965.*

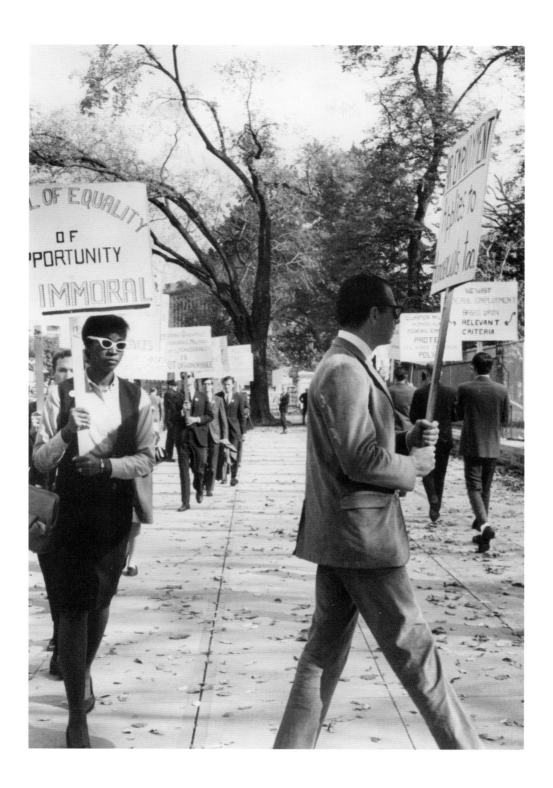

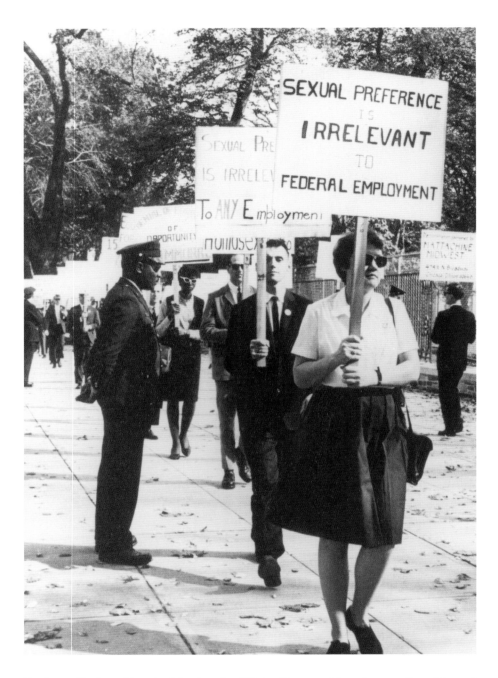

Barbara Gittings (front) picketing the White House with a sign reading, "Sexual preference is irrelevant to federal employment."

*Kay Tobin Lahusen, 1965.*

Frank Kameny marching in the picket line at Independence Hall.

*Kay Tobin Lahusen, 1966.*

Randy Wicker, an innovative activist whose work has spanned involvement in the Mattachine Society, the Homosexual League of New York, the Gay Activists Alliance, and the Radical Faeries, marches at the front of the picket line, holding a sign that says, "We don't dodge the draft . . . the draft dodges us!" He was one of the first people to advocate openly for LGBTQ rights on television and radio in the early 1960s, and he participated in many other demonstrations, including the pickets of the White House and the "sip-in" at Julius, a New York bar, in 1966.

*Kay Tobin Lahusen, 1965.*

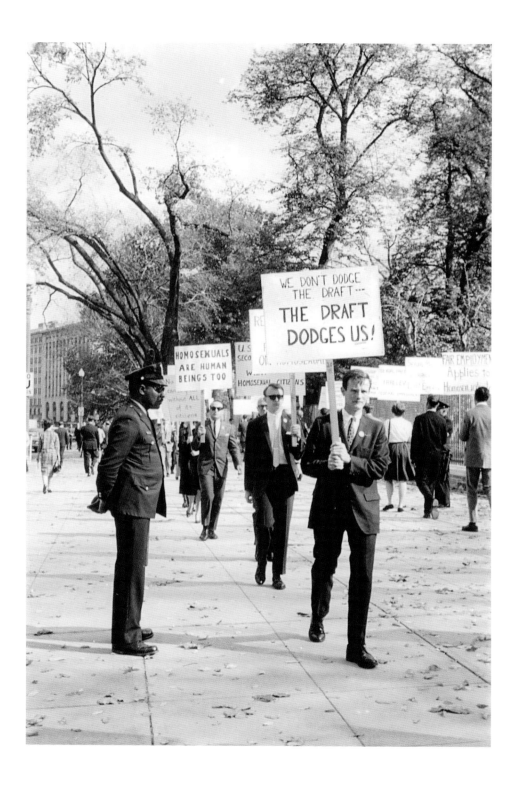

Marchers picketing the Pentagon. Lilli Vincenz is holding a sign that reads, "100,000 homosexual soldiers demand review of army policy." Vincenz was the first out lesbian to appear on the cover of a magazine, in a 1966 issue of *The Ladder* photographed by Lahusen. She was a member of the Daughters of Bilitis and the Mattachine Society of Washington, D.C., and cofounded the *Gay Blade*. Only a dozen marchers participated in this protest, but Lahusen was able to frame them for dramatic effect. She knew that this small fringe group of activists were part of a vanguard that was about to make history.

*Kay Tobin Lahusen, 1965.*

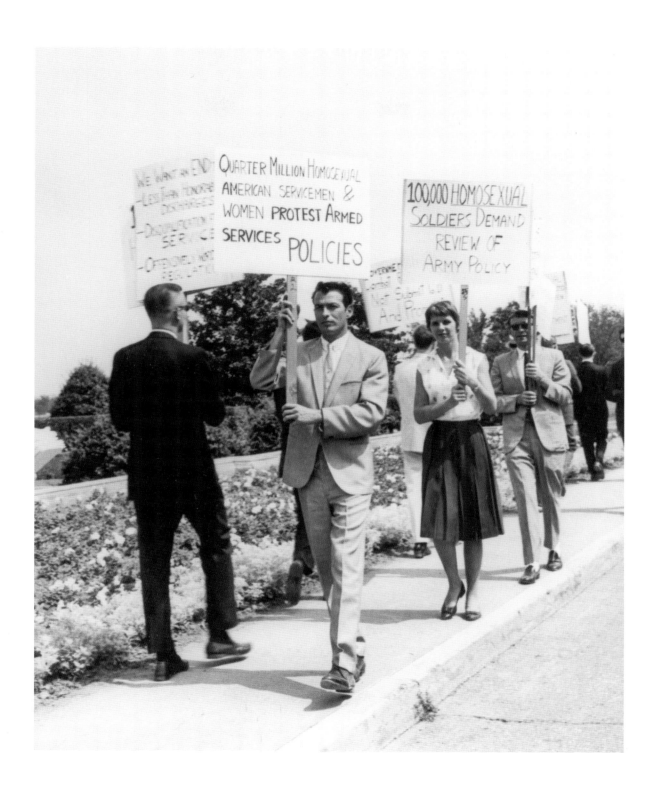

The 1966 "reminder day" protest. On July 4, 1965, demonstrators picketed Independence Hall in Philadelphia to protest the government's denial of fundamental rights and liberties to gays and lesbians. These protests were then repeated annually and were called "reminder day" protests because they were intended to remind the government, and society at large, that gays and lesbians were still denied legal equality. The marches continued until 1970, when the protest was moved to New York City to coincide with the anniversary of the Stonewall Riots.

*Kay Tobin Lahusen, 1966.*

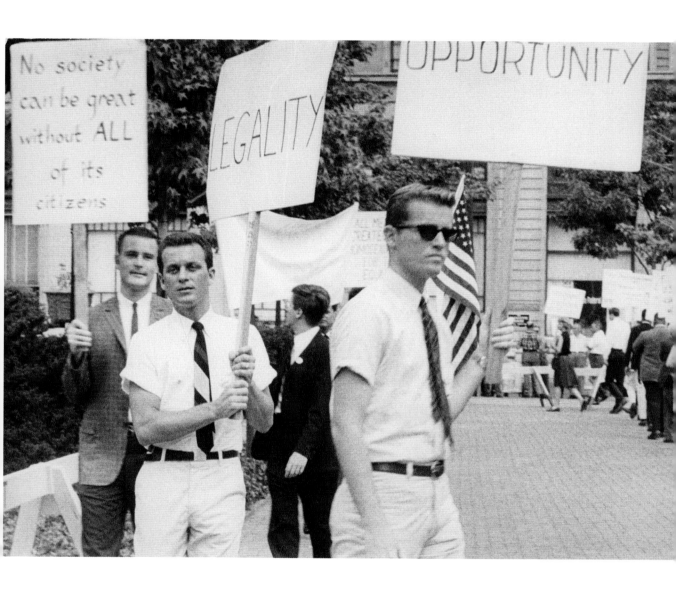

The Gay Liberation Front picketed *Time* magazine to protest its depictions of LGBTQ people in the October 31, 1969, issue. The *Time* article they protested, a story called "The Homosexual in America," while acknowledging societal prejudices, insisted that LGBTQ people were pitiable and maladjusted victims of arrested mental, emotional, and sexual development.

*Diana Davies, 1969.*

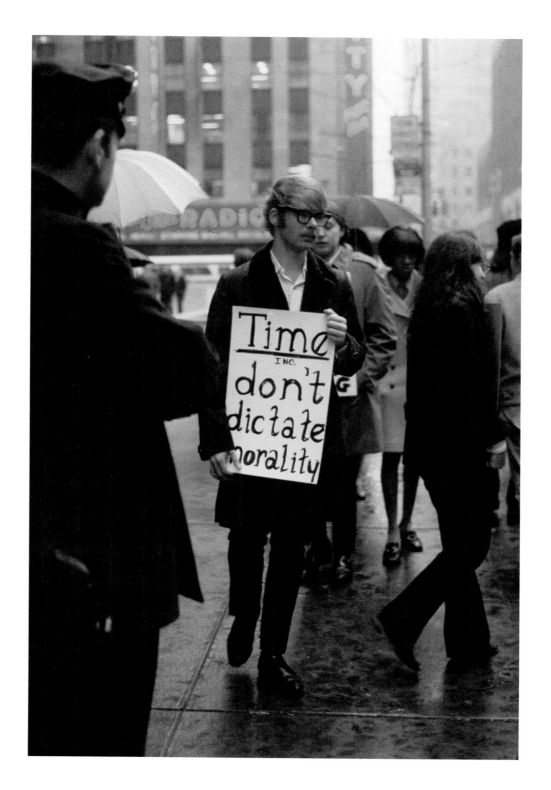

From left: GLF activists Linda Rhodes, Lois Hart, Ellen Broidy, and Jim Fouratt, who carries a sign reading, "Time Inc. / Don't dictate morality." Lois Hart was a key member of GLF and contributed extensively to their paper, *Come Out!* Rhodes and Broidy are activists who helped to organize the first Christopher Street Liberation Day march and participated in the Lavender Menace demonstration. Fouratt is an activist, journalist, and music industry professional who also participated in the Stonewall Uprising and ACT UP.

*Diana Davies, 1969.*

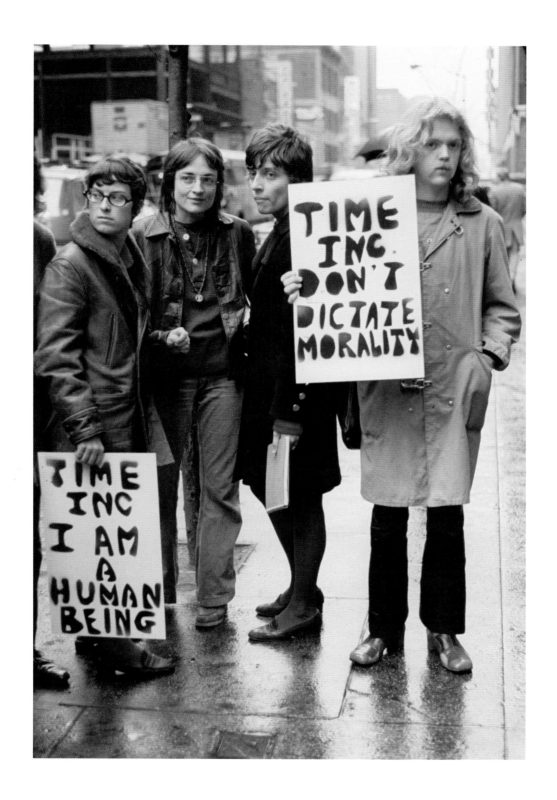

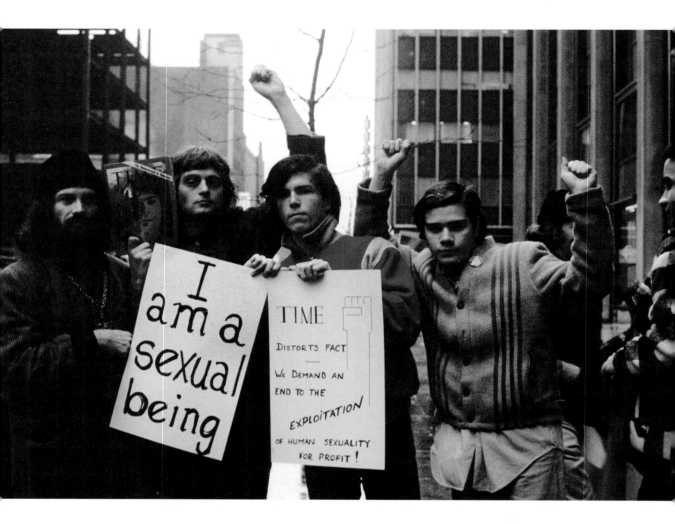

Protesters hold a copy of *Time* magazine, and signs reading "I am a sexual being," and "Time distorts fact / We demand an end to the exploitation / of human sexuality for profit." At far left is GLF member and psychic Leo Martello, founder of the Witches' Anti-Defamation League.

*Diana Davies, 1969.*

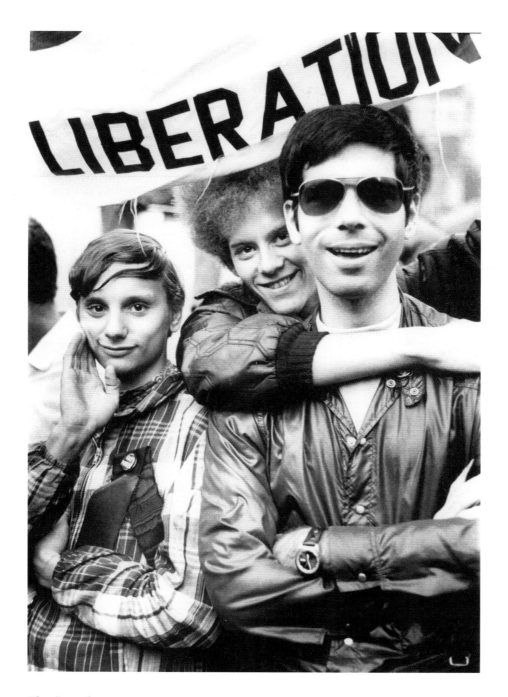

The Gay Liberation Front marches on Times Square, New York, 1969.

*Diana Davies, 1969.*

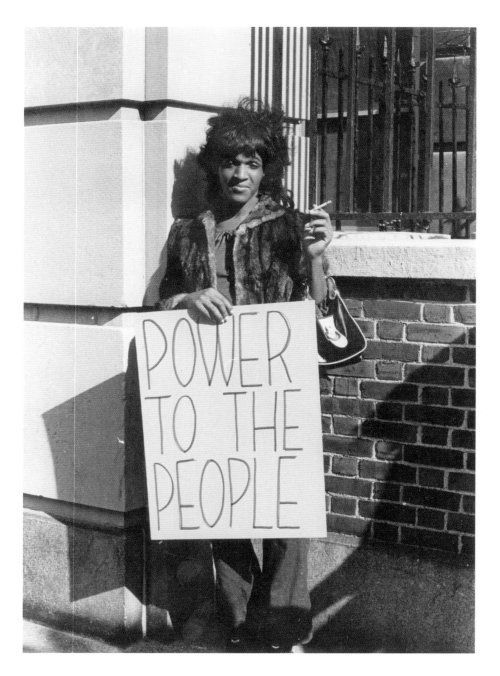

Marsha P. Johnson pickets New York City's municipal hospital, Bellevue, to protest its treatment of gay, homeless, and mentally ill people.

*Diana Davies, 1970s.*

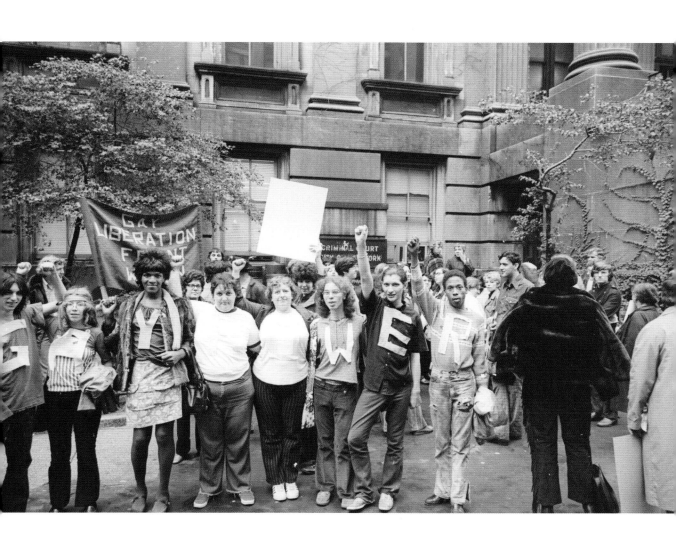

The women of Gay Liberation Front demonstrate at New York City's Criminal Courts Building.

*Diana Davies, 1970.*

The Rockefeller Five—Marty Robinson, Tom Doerr, Phil Raia, Jim Owles, and Arthur Evans—were arrested for criminal trespass on June 24, 1970, during a sit-in at the New York Republican State Committee. They were demanding that Governor Nelson Rockefeller meet with them to discuss the needs of the gay community, including repeal of New York State's sodomy and solicitation laws, an end to police entrapment, legislation outlawing discrimination on the basis of sexual orientation, an investigation of the State Liquor Authority, and an end to the harassment of gay bars throughout the state.

*Kay Tobin Lahusen, 1970.*

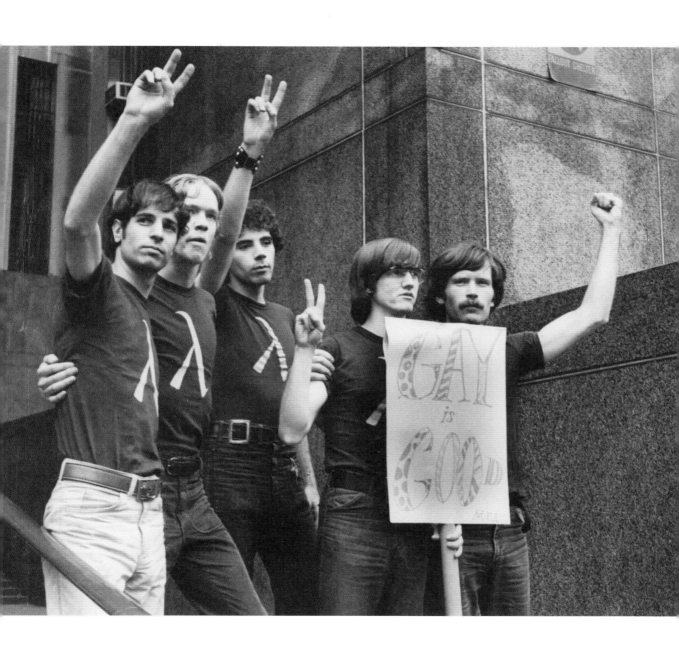

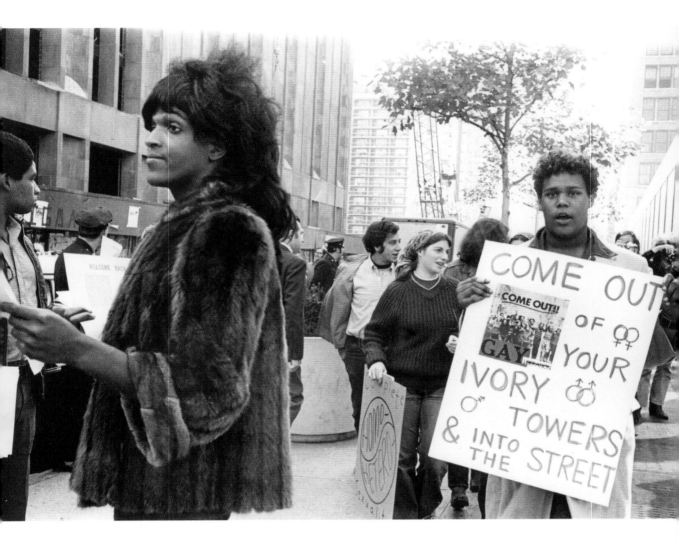

Marsha P. Johnson hands out flyers in support of LGBTQ students at New York University. In 1970, NYU's Gay Student Liberation Association occupied the university's Weinstein Hall to protest its refusal to allow the group to host gay dances on campus.

*Diana Davies, 1970.*

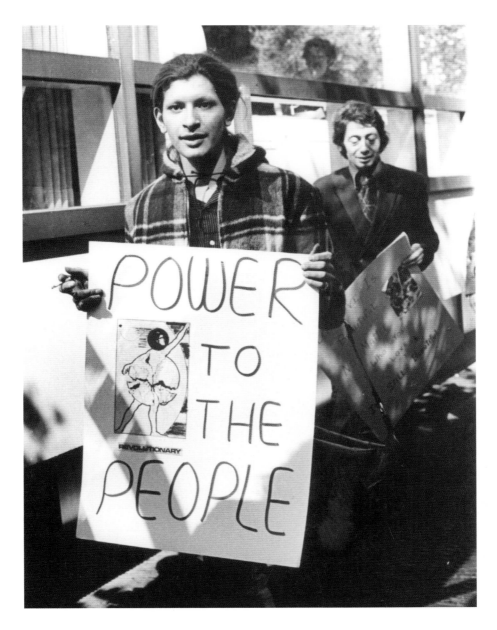

Sylvia Rivera (front) and Arthur Bell march at the Gay Student Liberation demonstration at New York University. Arthur Bell was an activist and writer for the *Village Voice*. His memoir *Dancing the Gay Lib Blues* (1971) details his experiences in the gay liberation movement.

*Diana Davies, 1970.*

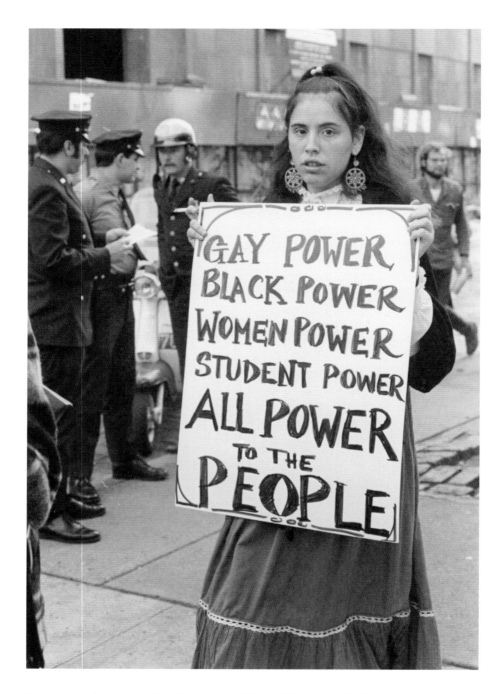

Daria Fane demonstrating for human rights at Weinstein Hall protest.

*Diana Davies, 1970.*

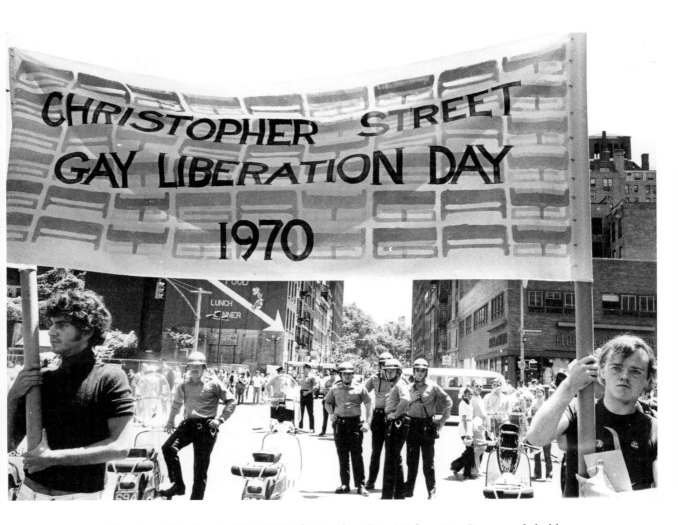

People at the front of the 1970 Christopher Street Liberation Day march holding a banner.

*Diana Davies, 1970.*

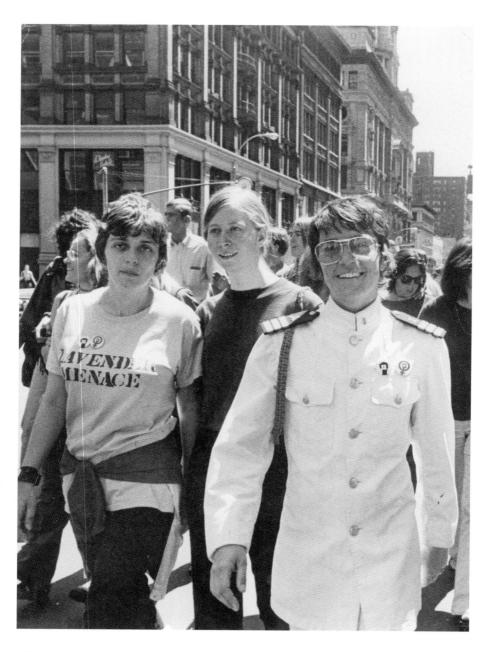

Ellen Broidy in a "Lavender Menace" T-shirt, Dolores Bargowski (center), and Rita Mae Brown (right) march in the Christopher Street Liberation Day celebration.

*Diana Davies, 1970.*

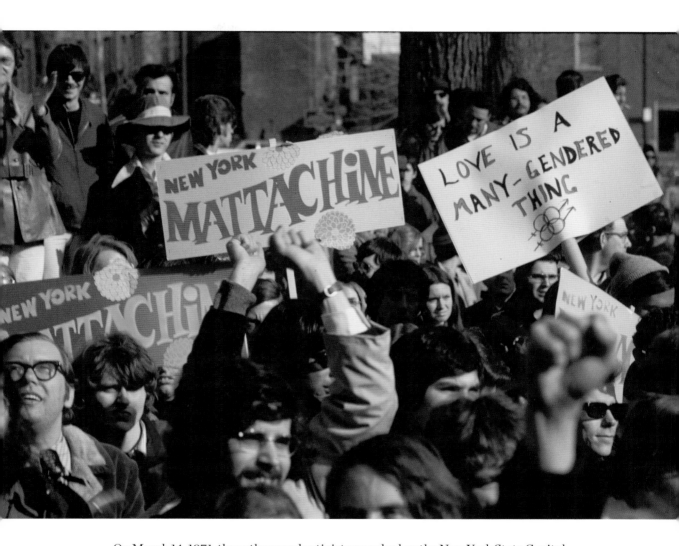

On March 14, 1971, three thousand activists marched on the New York State Capitol in Albany to demand repeal of the state's sodomy, solicitation, and impersonation laws, as well as to demand the passage of employment and housing protections for LGBTQ people.

*Diana Davies, 1971.*

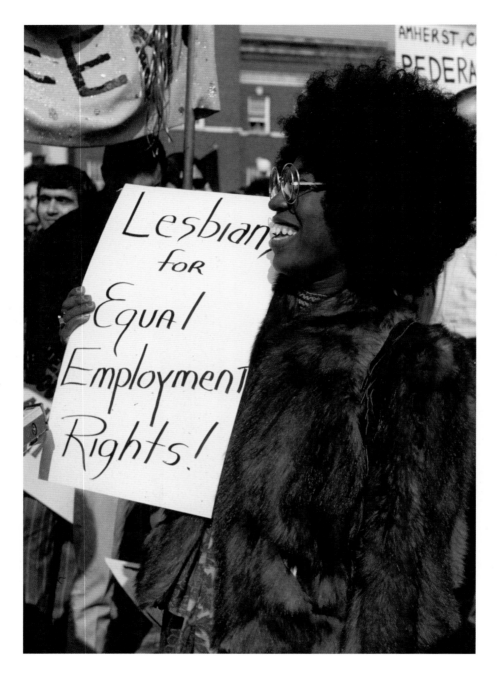

Marcher in Albany carrying a "Lesbians for Equal Employment Rights" sign.

*Diana Davies, 1971.*

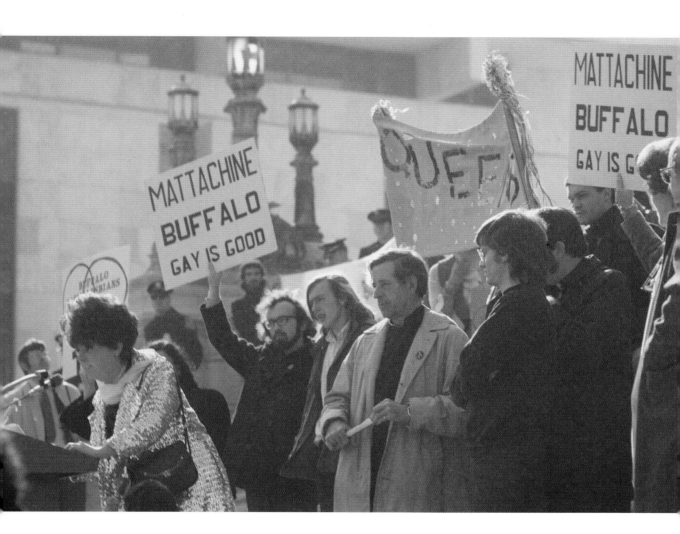

Activist Lee Brewster speaking at the 1971 Albany rally. Brewster was a veteran of the Mattachine Society in the 1960s, edited the magazine *Drag Queens* in the 1970s, and led the Queens Liberation Front, which fought to "gain the legal right for everyone who so desires to crossdress regardless of their sexual orientation."

*Diana Davies, 1971.*

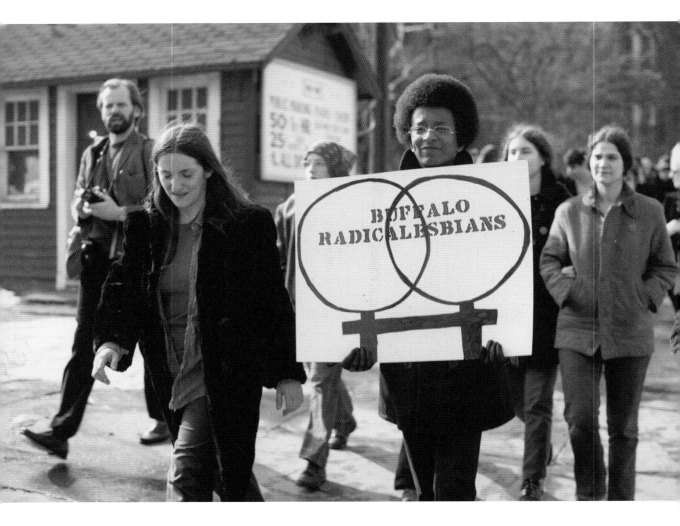

Demonstrators in the 1971 Albany march came from gay liberation, radical lesbian, and transgender liberation organizations all over New York State, including Buffalo, Long Island, Binghamton, Ithaca, Syracuse, Rochester, and Watertown, as well as groups visiting from Massachusetts.

*Diana Davies, 1971.*

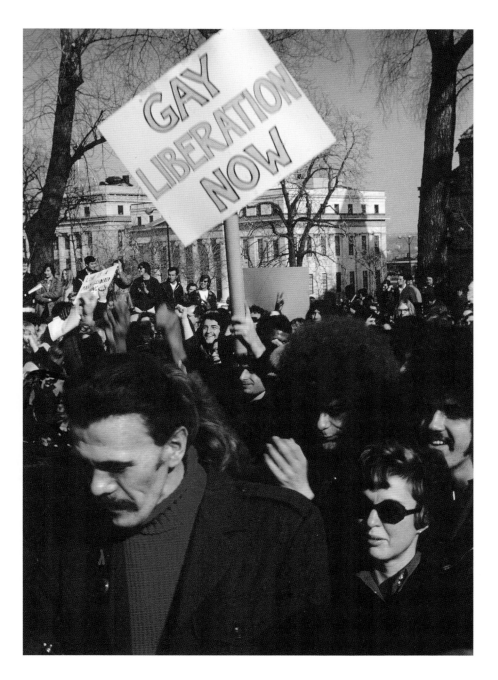

Demonstrators beneath "Gay Liberation Now" sign at the Albany rally.

*Diana Davies, 1971.*

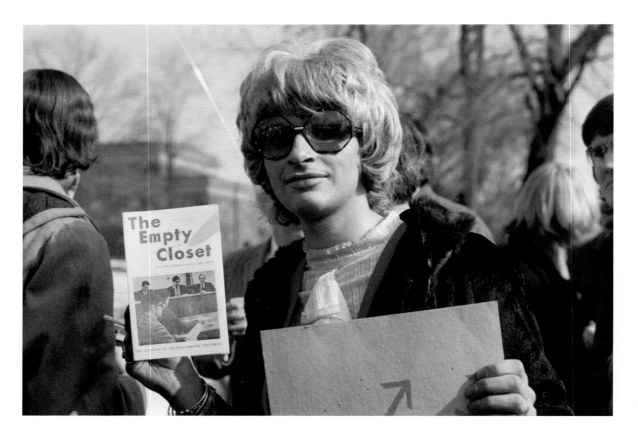

Sylvia Rivera in Albany carrying a copy of *The Empty Closet* magazine, published by the Gay Liberation Front students' group at the University of Rochester.

*Diana Davies, 1971.*

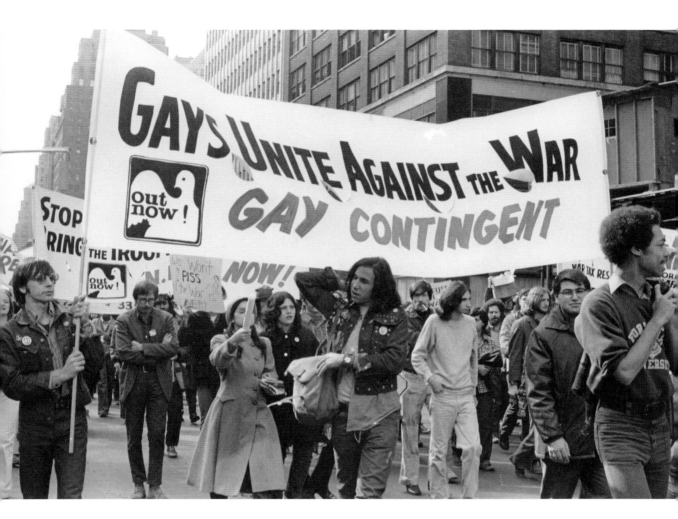

A gay contingent marching in a Vietnam War protest march.

*Diana Davies, 1971.*

Barbara Gittings (in print dress) and Isabel Miller, kissing at a booth called "Hug a Homosexual" at the 1971 American Library Association (ALA) convention. When ALA's Task Force on Gay Liberation formed in 1970, it was the first LGBTQ professional organization in the United States, and it became a major focus of Gittings's activism. At this 1971 convention, the task force distributed three thousand copies of their "Gay Bibliography" and hosted this "Hug a Homosexual" booth to garner publicity. Isabel Miller was the pseudonym of activist and writer Alma Routsong, who in 1971 won the first Stonewall Book Award for her novel *Patience and Sarah*.

*Kay Tobin Lahusen, 1971.*

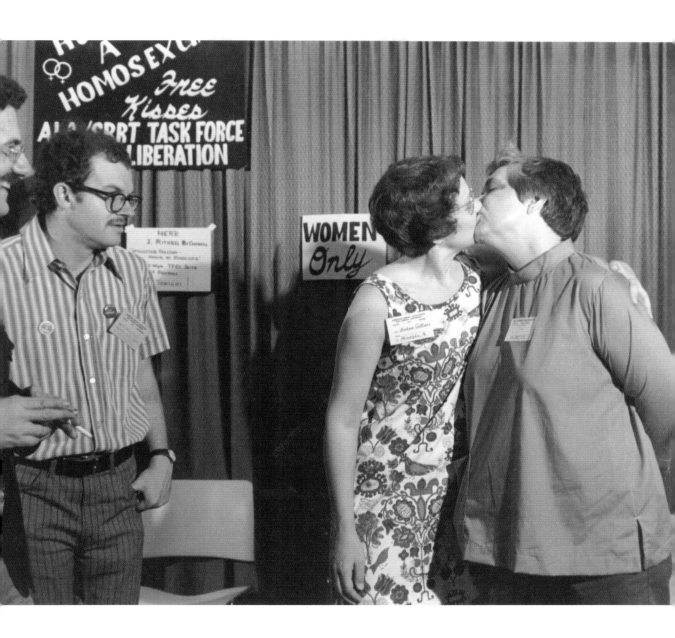

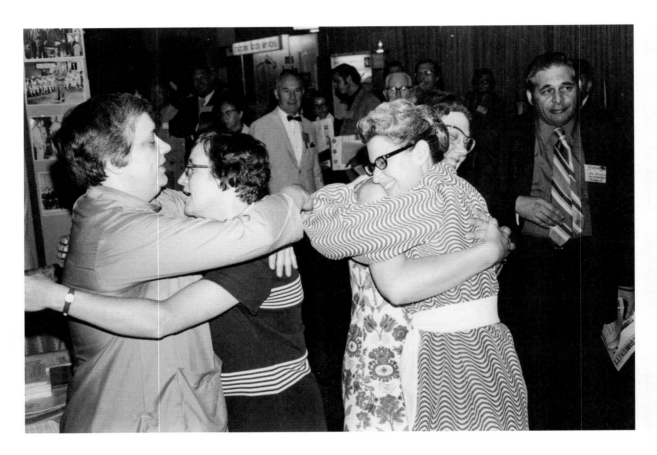

Isabel Miller and Barbara Gittings hugging librarians at the ALA "Huga Homo-
sexual" booth.

*Kay Tobin Lahusen, 1971.*

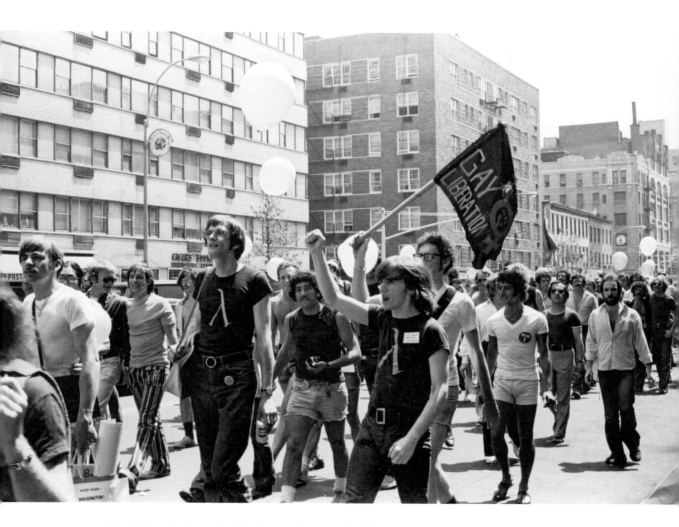

Jim Owles (with raised fist) marching in the Christopher Street Liberation Day
protest. Owles was the first president of the Gay Activists Alliance, the first openly
gay person to run for office in New York City, and a founding member of GLAAD.

*Kay Tobin Lahusen, 1971.*

Activists holding signs reading, "Gay liberation now" and "Out of the closets / into the streets," for Christopher Street Liberation Day. At left is Craig Rodwell; behind him is Marsha P. Johnson; at right Kady Van Deurs; and in the center is Bob Kohler.

*Diana Davies, 1971.*

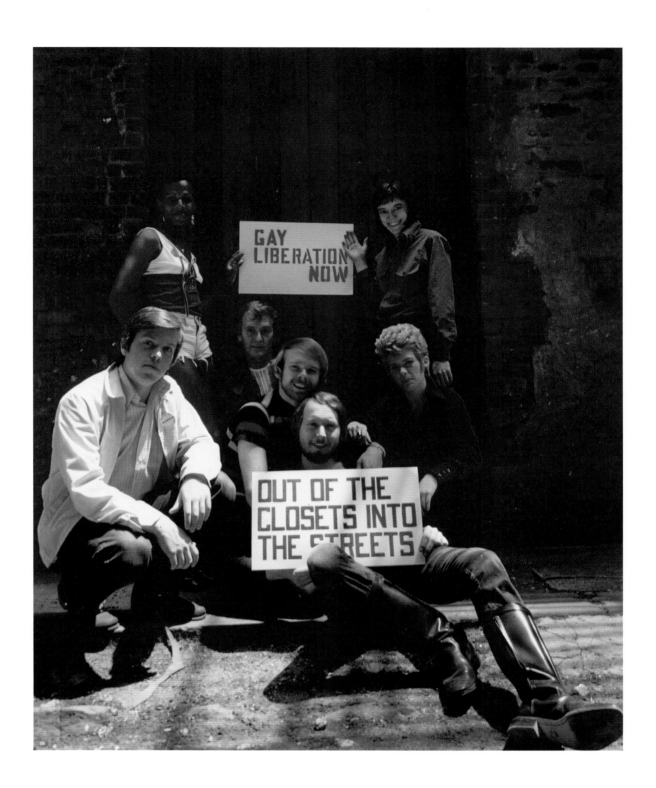

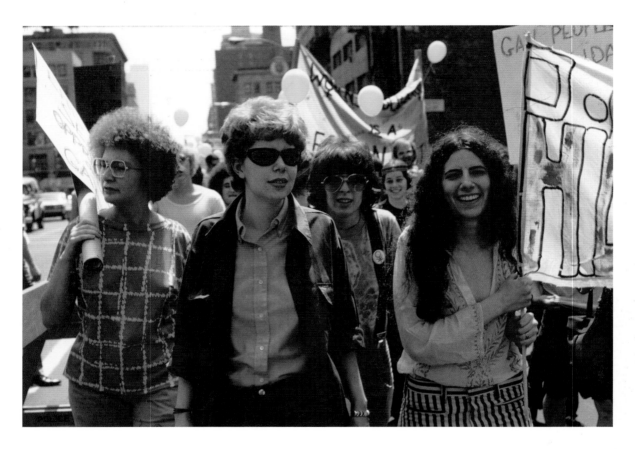

Women marching in Christopher Street Liberation Day, 1971.

*Diana Davies, 1971.*

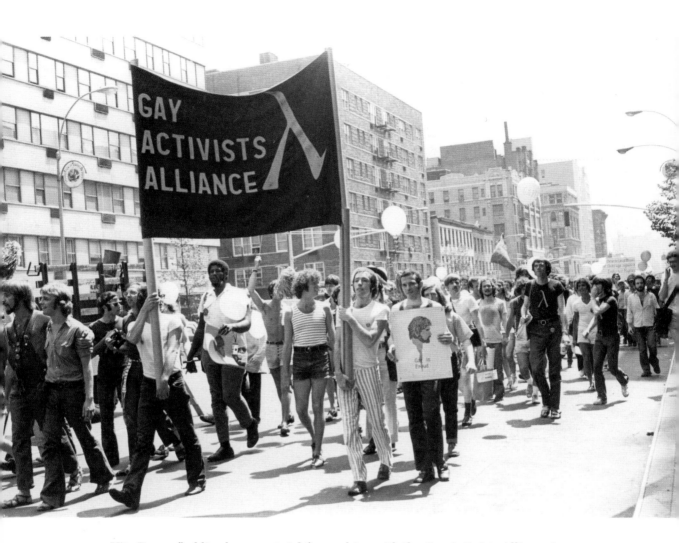

Vito Russo (holding banner at right) marching with the Gay Activists Alliance in Christopher Street Liberation Day. Russo was an activist and writer. He was a pivotal member of GAA and, later, ACT UP New York, and wrote *The Celluloid Closet*, a history of the depictions of gays and lesbians in film, which was later made into a documentary.

*Kay Tobin Lahusen, 1971.*

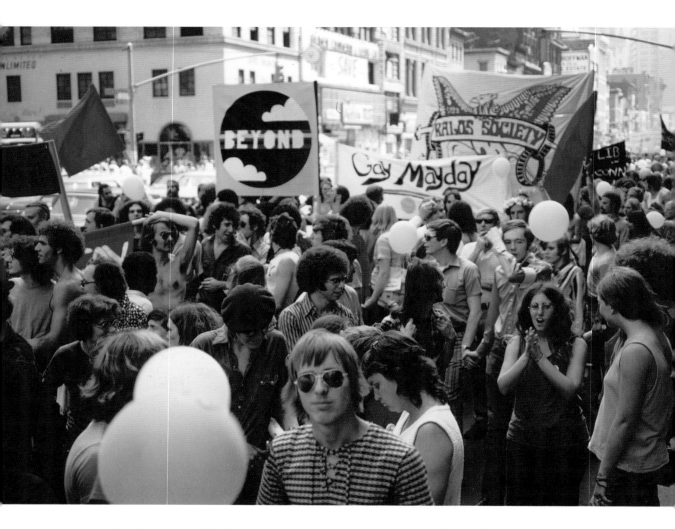

Gay Mayday and Kalos Society demonstrators march for Christopher Street Liberation Day. Gay Mayday was a contingent of gay liberation activists who participated in the massive May Day protests held in 1971 in Washington, D.C., against the Vietnam War. The Kalos Society was a gay liberation group in Connecticut that emerged in 1968.

*Diana Davies, 1971.*

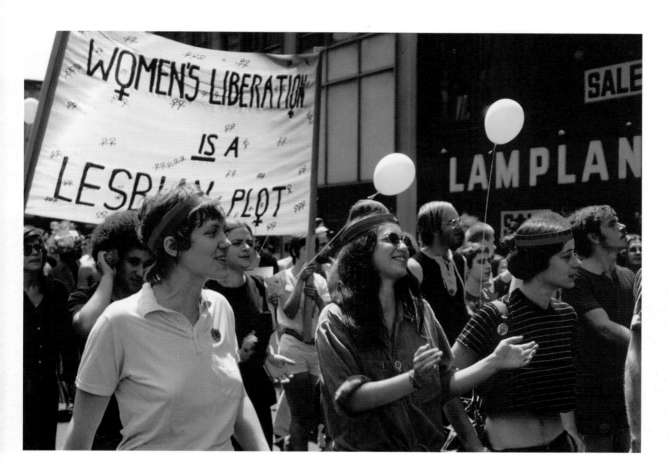

Marchers carrying a banner reading, "Women's Liberation <u>Is</u> a Lesbian Plot" at Christopher Street Liberation Day 1971. This was a slogan from the Lavender Menace protest as well as a critique of those who would try to push lesbians out of the feminist movement.

*Diana Davies, 1971.*

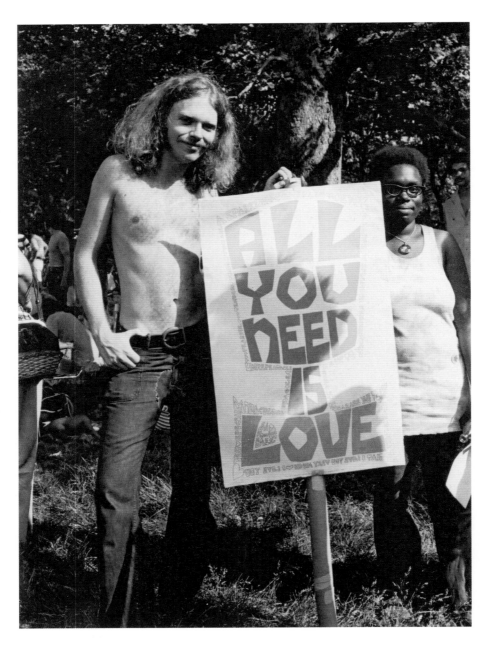

Marchers with an "All You Need Is Love" sign at New York's Christopher Street
Liberation Day, 1971.

*Kay Tobin Lahusen, 1971.*

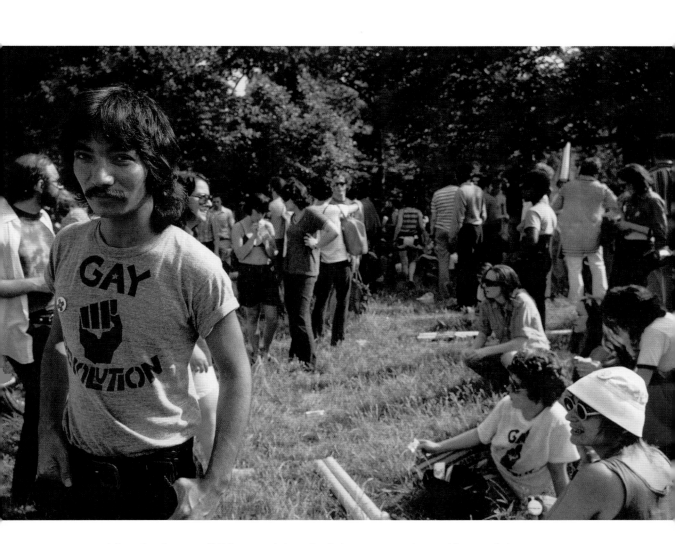

After the Stonewall Riots, activists shed the conservative uniforms of the 1960s protests to express their own unique styles and identities, like this man in a "Gay Revolution" T-shirt.

*Diana Davies, 1971.*

In 1972, Barbara Gittings (left), Frank Kameny (center), and John E. Fryer (right, wearing a mask and using the pseudonym "Dr. H. Anonymous") testified at an American Psychiatric Association (APA) panel billed as "Psychiatry: Friend or Foe to Homosexuals: A Dialogue." Fryer was a gay psychiatrist who agreed to testify anonymously at the panel using a voice-altering microphone. The trio's testimony at the panel was a turning point in the psychiatric profession's views of homosexuality. The APA removed homosexuality from its schedule of mental illnesses in 1973.

*Kay Tobin Lahusen, 1972.*

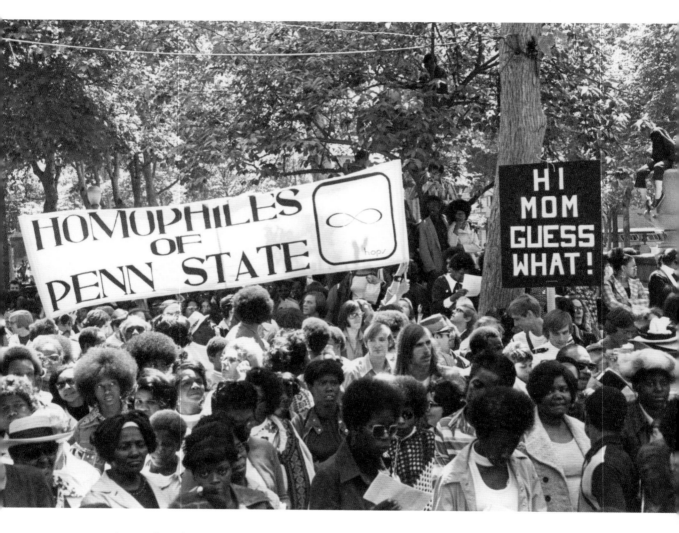

A crowd with signs reading, "Homophiles of Penn State" and "Hi Mom / Guess What!" march at the 1972 Philadelphia pride rally.

*Kay Tobin Lahusen, 1972.*

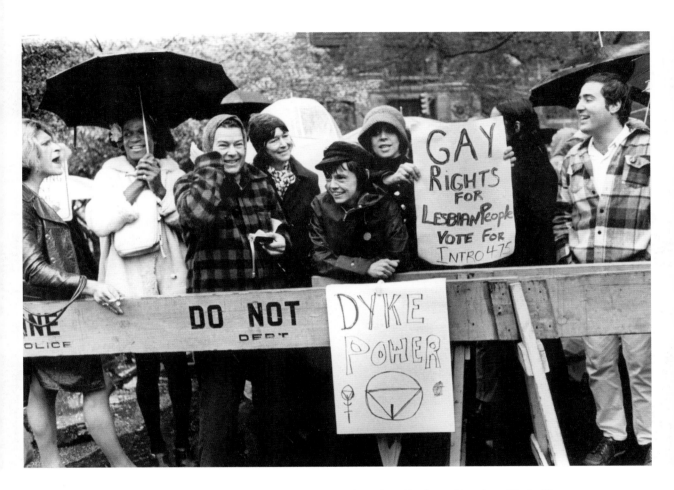

Sylvia Rivera, Marsha P. Johnson, Jane Vercaine, Barbara Deming, Kady Van
Deurs, Carol Grosberg, and others demonstrate at New York's City Hall in support
of gay rights bill Intro 475.

*Diana Davies, 1973.*

Kady Van Deurs and Marsha P. Johnson march at a rally in support of Intro 475 at City Hall in New York City. Intro 475, first introduced in 1971, was a bill prohibiting employment and housing discrimination in New York City due to sexual orientation. Legislation protecting against discrimination due to sexual orientation was not adopted in New York City until 1986, and not until 2002 for gender identity.

*Diana Davies, 1973.*

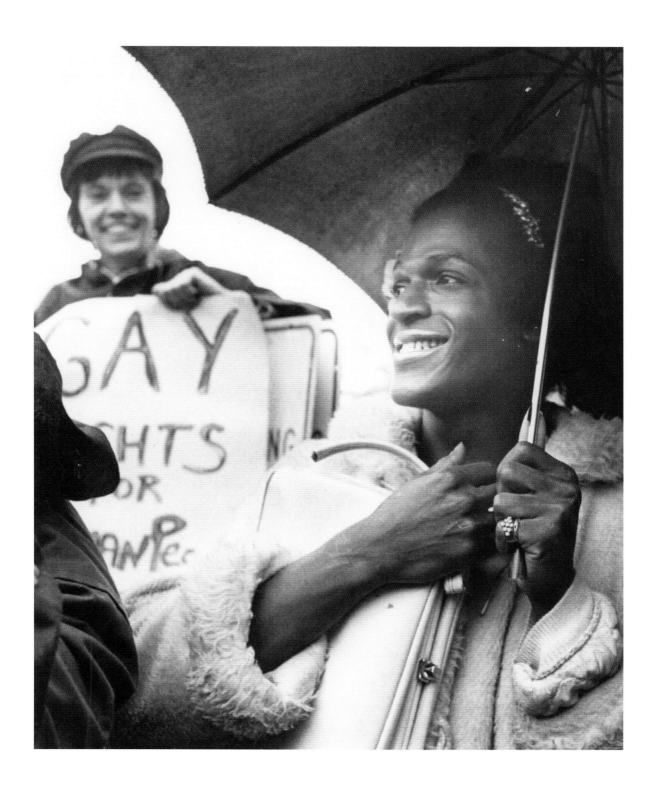

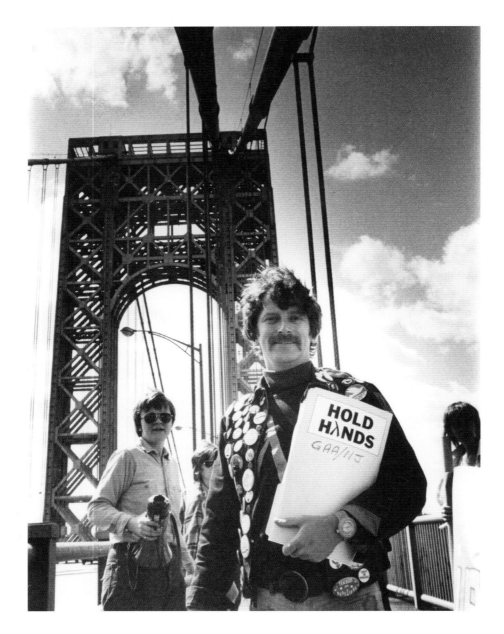

In May 1973, the Gay Activists Alliance of New Jersey had a "Hold Hands" demonstration, with five hundred activists holding hands across the George Washington Bridge in order to promote "gay love, gay pride, and gay solidarity."

*Diana Davies, 1973.*

# Acknowledgments

With thanks to Carrie Welch and the leadership of the New York Public Library for their partnership in the making of this book, and to Carey Maloney and Hermes Mallea for their ongoing support. Special thanks to the New York Community Trust and TD Bank for their funding of the 2019 "Love and Resistance: Stonewall at 50" exhibition and accompanying programs. Additional thanks to the activists and scholars who have shared their insights on these photographs, including Ellen Broidy, Steven Dansky, Jim Fouratt, Marcia Gallo, and Eric Marcus.

# Suggestions for Further Reading

I have provided brief annotations of the photographs to acquaint the reader with the people and events depicted. However, a comprehensive narrative would be beyond the scope of this volume. Those eager to learn more about this rich and important history may consult the following books, which have been essential in my own understanding of the context of these photographs.

Baim, Tracey. *Barbara Gittings: Gay Pioneer*. Chicago: Prairie Avenue Productions, 2015.

Carter, David. *Stonewall: The Riots That Sparked the Gay Revolution*. New York: St. Martin's, 2004.

Clendinen, Dudley, and Adam Nagourney. *Out for Good: The Struggle to Build a Gay Rights Movement in America*. New York: Simon & Schuster, 1999.

Cohen, Stephan L. *The Gay Liberation Youth Movement in New York: "An Army of Lovers Cannot Fail."* New York: Routledge, 2008.

Davies, Diana. *PhotoJourney: Photographs*. Belfast, Maine: Bag Lady Press, 1989.

D'Emilio John. *Sexual Politics, Sexual Communities: The Making of a Homosexual Minority in the United States, 1940–1970*. Chicago: University of Chicago Press, 1998.

Duberman, Martin. *Stonewall*. New York: Dutton, 1993.

Echols, Alice. *Daring to Be Bad: Radical Feminism in America, 1967–75*. Minneapolis: University of Minnesota Press, 1989.

Faderman, Lillian. *The Gay Revolution: The Story of the Struggle*. New York: Simon & Schuster, 2015.

Gallo, Marcia. *Different Daughters: A History of the Daughters of Bilitis and the Rise of the Lesbian Rights Movement*. New York: Carroll & Graf, 2006.

Gossett, Reina, Eric A. Stanley, and Johanna Burton. *TRAP Door: Trans Cultural Production and the Politics of Visibility*. Cambridge: MIT Press, 2017.

Jay, Karla. *Tales of the Lavender Menace: A Memoir of Liberation*. New York: Basic Books, 1999.

Jay, Karla, and Allen Young. *Out of the Closets: Voices of Gay Liberation*. New York: New York University Press, 1992.

Mecca, Tommi Avicolli. *Smash the Church, Smash the State! The Early Years of Gay Liberation*. San Francisco: City Lights Books, 2009.

Meyerowitz, Joanne. *How Sex Changed: A History of Transsexuality in the United States*. Cambridge: Harvard University Press, 2002.

Stein, Marc. *City of Sisterly and Brotherly Loves: Lesbian and Gay Philadelphia, 1945–1975*. Chicago: University of Chicago Press, 2000.

Stryker, Susan. *Transgender History*. Berkeley Calif.: Seal Press, 2008.

Tobin, Kay, and Randy Wicker. *The Gay Crusaders*. New York: Paperback Library, 1972.

# Index